LINCOLNSHIRE INDUSTRIAL HERITAGE

T0312851

Colin Tyson

AMBERLEY

Front cover: Bass Maltings, Sleaford.
Back cover: Workers underground at Nettleton Top Mine.

All photographs are by the author, unless otherwise stated. Thanks are due to Phil Barnes, Chris Bates, Simon Colbeck, Barry Coward, Darren Hendley, Andrew Neale and Richard Pullen for their help with research and photography.

First published 2022

Amberley Publishing
The Hill, Stroud
Gloucestershire, GL5 4EP

www.amberleybooks.com

British Library Cataloguing in Publication Data.
A catalogue record for this book is available from the British Library.

ISBN 978 1 4456 8846 6 (print)
ISBN 978 1 4456 8847 3(ebook)

Typesetting by SJmagic DESIGN SERVICES, India.
Printed in Great Britain.

Contents

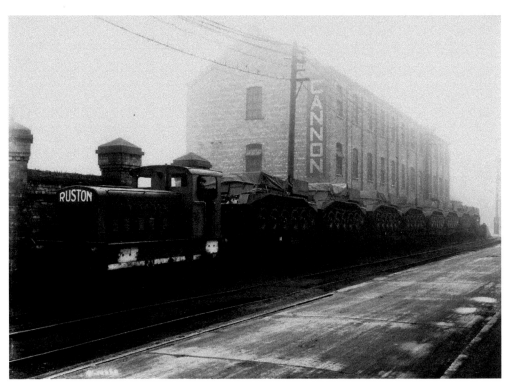

One week's worth of Ruston's Second World War production output parked up outside the Cannon Glue Works off Firth Road, Lincoln... (Richard Pullen Collection)

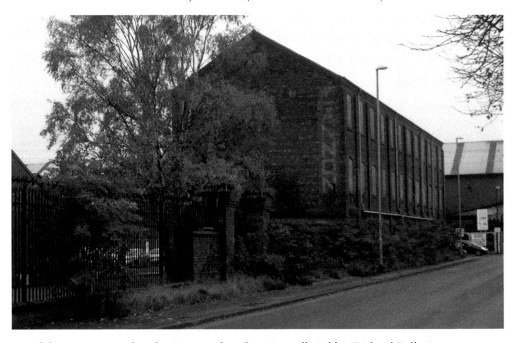

...and the same view today, the Cannon ghost lettering still visible. (Richard Pullen)

Introduction

Although I was born and raised in Sussex, I consider Lincolnshire my 'adoptive county' as I spent two decades there, becoming familiar with many of the sites featured in this book while editor of the Lincolnshire-based international steam engine and industrial heritage magazine *Old Glory*. I can also trace my paternal line in Lincolnshire back to the time of the Stuart dynasty, when they were farming in Gayton-Le-Marsh. Although originally a Cumberland name, I wonder if the 'Tyson' of Tyson's watermill in Tealby was a relative?

If Kent is the 'Garden of England' then the large county of Lincolnshire is nowadays associated with food production and could be the 'Market Garden of England'. Visible remains of the methods that were once used to process and transport perishable goods to the county's industrial towns and ports are still in evidence if you know where to look.

Maltings were built in several towns to service the barley market to produce beer and survive in number, alongside warehouses, wharves and other evidence of former industries.

Much of the Lincolnshire 'flat' fenland carries historic drainage ditches and water courses and with them came a large amount of water pumping stations, built to harness the incoming tides, while watermills used this natural resource to be productive.

Industrial towns such as Grimsby, Immingham and Scunthorpe grew along the banks of the River Humber while Lincoln, Gainsborough and Boston saw successful agricultural engineering manufacturing facilities that provided steam power to the Industrial Revolution, both to Britain and around the world.

The internet has become a valuable resource to the industrial archaeologist, although a degree of caution needs to be exercised over accuracy in some cases. I have found the National Library of Scotland's Georeferenced maps website of great help in showing a selection of Ordnance Survey maps from the 1890s onwards, displayed side by side with modern satellite mapping (www.maps.nls.uk/geo). Referencing these maps will help you to discover places for yourselves that once played their part in the working environment of Lincolnshire.

I hope you will be sufficiently enthused to explore some of these sites for yourself as you discover a little more about how our ancestors made their living. Please respect the privacy of occupiers of privately owned buildings and please do not trespass.

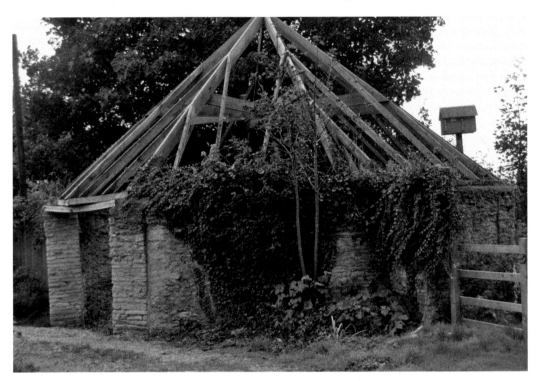

A rare survival from pre-mechanisation days, this gin house for a bone mill at Brauncewell near Sleaford of *c.* 1800 originally had a thatched roof. The horse was tethered to a beam across the top. It can be viewed from the road through the village.

Chapter 1

Agricultural Engineering

With farming playing such a large role in Lincolnshire, it was no surprise that back street blacksmiths turned their hand to playing their part in the development of the steam engine during the Industrial Revolution. This included the portable engine that could be moved around the farm by horse and provided power for such tasks as lighting and crushing cattle cake, as well as traction engines that could be belted to equipment like power-threshing machines and saw benches. Lincoln was a hotbed of such manufacturing activity.

Aveling-Barford Ltd, Grantham
In 1933 Mr Edward Barford MC formed Aveling-Barford Ltd by bringing together the two former well-known concerns of Barford & Perkins Ltd of Peterborough, Northants (founded 1840), and Aveling & Porter Ltd of Rochester, Kent (founded 1850), into a single trading company.

Such a move required the acquisition of new premises and 35 acres of land were located and purchased at Grantham, Lincolnshire, adjacent to the LNER's main east coast route to Scotland.

The move north from the old Aveling premises at Rochester started in October 1933 – involving nearly 10,000 tons of machinery, paint stores, drawing office tools and jigs and the contents of the general office.

At the time this was probably the largest factory removal to have taken place in the country. The location of the new site was a great help, with numerous sidings next to the main line enabling each van to be unloaded and placed in their new location. The new works was in operation early in 1934.

In 1937 the company introduced a new range of steam rollers. These came about as a result of the company being members of 'AGE' (Association of Agricultural & General Engineers), an organisation that brought engine and agricultural equipment manufacturers into one large marketing organisation 'to mutual benefit'. In this case, Aveling-Barford were the nominated company to sell steam rollers, regardless of the origin.

Thus the new range of rollers were designed by Rustons, Vickers and Davey-Paxman. This organisation ultimately folded, with the result that many of its constituent companies went out of business, although a fair number survived the hiatus.

Aside from their famous diesel rollers, from the 1940s the firm was known for its range of dump trucks, calf dozers, motor graders and front loaders for the construction industry, which today are still manufactured elsewhere by Invictas Engineering and sold under the Barford name, retaining the original logo of Kent's rampant horse as a nod to its Aveling of Rochester origins.

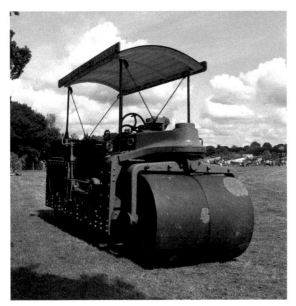

Left: Barford & Perkins of Peterborough became one of the concerns to merge in 1933 to form Aveling-Barford at Grantham. Their rare surviving B&P Type Q6 motor roller of 1926 was restored in 2017. (Alan Barnes)

Below: Aveling-Barford 6-ton roller No. AC 624 of 1938. Just over twenty steam rollers have survived in the UK from this manufacturer. (Old Glory Archive)

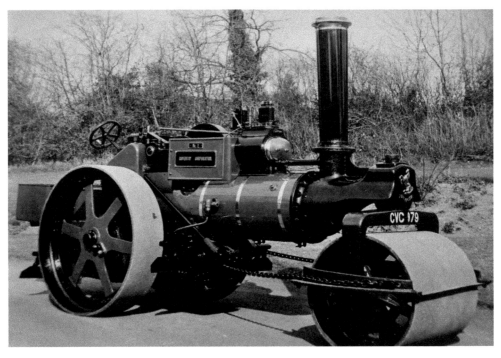

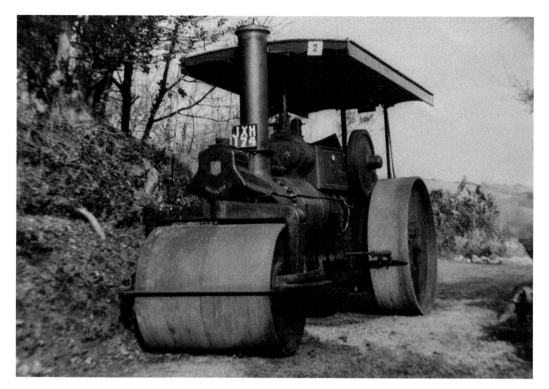

The larger 10-ton Aveling-Barford roller No. AH162 of 1948. (Old Glory Archive)

Clayton & Shuttleworth Ltd, Lincoln

Nathaniel Clayton and his brother-in-law Joseph Shuttleworth began trading in Lincoln in 1842 at the Stamp End Works. Nathanial was a steam packet boat master and owner of a small iron foundry and Joseph was a boatbuilder. Their first large contract was to supply water pipes for the Miningsby Reservoir to Boston water supply scheme. Soon the world was beating a path to their doors to buy Clayton & Shuttleworth portable steam engines and threshing machines. They produced their first steam portable engines in 1845 and the first threshing machine in 1848. By 1890 the company had built over 26,000 steam engines and 24,000 threshing machines. The first Clayton traction engine recorded was No. 2315, a single-cylinder 7 hp engine built on 2 July 1857. Their one hundredth engine was No. 9338, a double-cylinder 10 hp machine built on 10 August 1869. They quickly moved into other markets and were soon building petrol-engined tractors. During the First World War they built Sopwith aircraft and huge Handley-Page bombers. By the end of the war, the factory had spread, with an eclectic mix of workshops, hangers and other structures covering almost every inch of the site. The 1920s were difficult and the factory was split up and occupied by Clayton-Dewandre Ltd and Smith Clayton Forge. Much of the old works still survives today, but undoubtedly the most impressive and recognisable standing industrial structure in Lincoln today has to be the Clayton & Shuttleworth 'Titanic Works'. Opened in 1912, the works were so called because the main building was the same length and width as the famous ship.

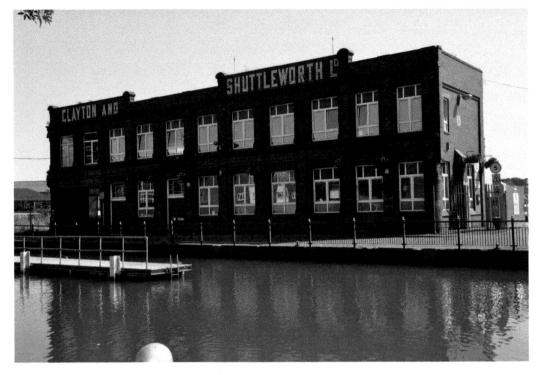

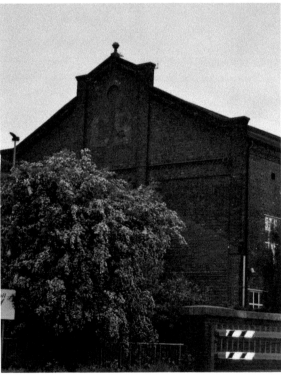

Above: The surviving former main offices of Clayton & Shuttleworth.

Left: The lettering 'CS' survived on the west wall of the works until relatively recently.

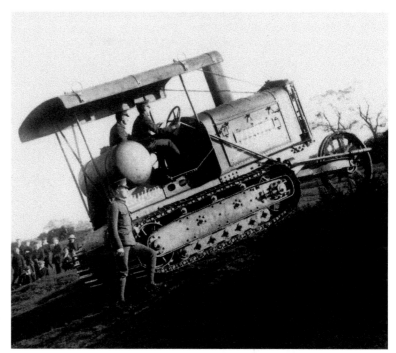

Right: War work: an early Clayton tractor undergoing military tests on Lincoln's South Common attracts an audience.

Below: Clayton & Shuttleworth exports. Repatriated from Argentina is ploughing engine No. 48502 of 1908 and Colonial Tandem engine No. 92885 of 1910. (Simon Colbeck)

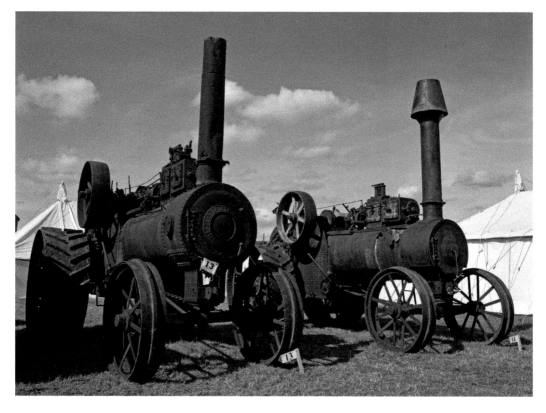

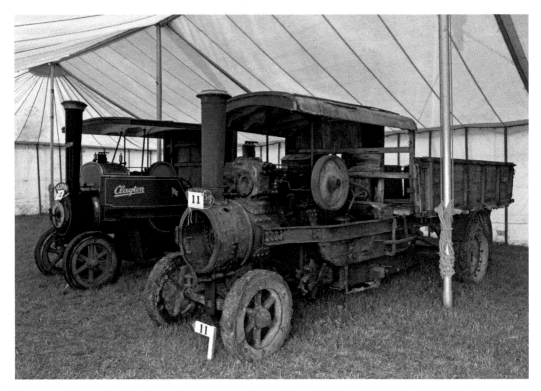

Two rare Clayton & Shuttleworth wagon survivors – Nos 48347 and 48308, both built in 1919. (Simon Colbeck)

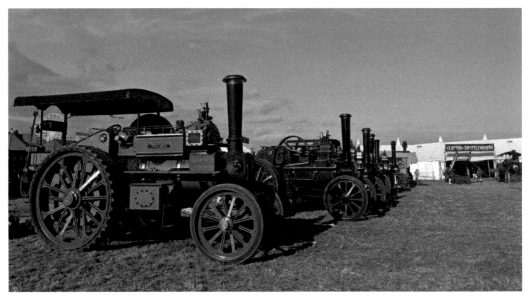

Clayton & Shuttleworth engines line-up at the 'Built in Lincoln' display, Great Dorset Steam Fair 2019. (Simon Colbeck)

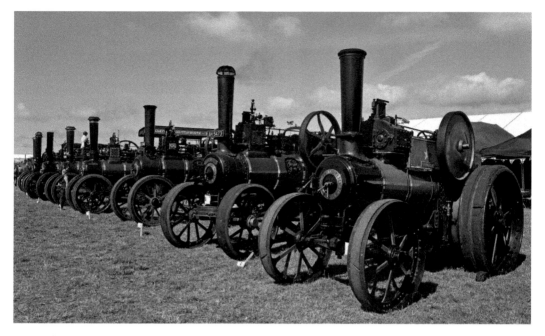

Clayton & Shuttleworth traction engines with General Purpose Engine *Dorothy* of 1914 nearest the camera. (Simon Colbeck)

Wm. Foster & Co. Ltd, Lincoln

William Foster was born in Potterhanworth, Lincs, in 1816 and moved from flour milling on the Witham to engineering machinery for millers in 1856. A year later he was producing threshing machines and in 1861 exhibited portable steam engine No. 64 at the Smithfield Show. Successes included straw-burning engines for the South American market from around 1900, and the firm was awarded the silver medal for its 'Wellington' tractor at the RAC Trials in 1907.

The once great Wellington Foundry was off Firth Road in the south of the city and was world-famous for producing top quality steam traction engines, threshing machines and even lamp posts. Their steam range spanned the useful little 'Wellington' tractor, massive showman's engines, 5-ton steam wagons and even petrol-engined tractors, but they will perhaps be best known outside the world of steam for their inspired work during the First World War when they built a prototype tank in just thirty-nine days. In September 1916 the first batch of tanks left Fosters for the Battle of the Somme. Unfortunately, for an innovative company that produced several world firsts, Fosters seem to have been slow to adapt to changing markets and ended up in financial trouble soon after the First World War. In 1927 Fosters teamed up with Gwynnes Pumps Ltd of Hammersmith and started producing pumps, some of which were huge, largely for land drainage.

They managed to cling on until 1968 when they finally closed. The old factory site was bought by Ruston-Bucyrus Ltd, who used parts of it for storage until in the 1980s it was demolished and soon William Foster & Co. Ltd, or Foster-Gwynnes as they were known by then, was just a memory.

Perhaps the saddest industrial survival story in Lincoln, today the only surviving part of the works is a section of brick wall behind a coffee shop – not much to show for this once proud company. A nearby roundabout includes metal artwork of a tank at its centre.

Happily, one of Foster's original agents, Dawson's of Bicker, Boston, having purchased Foster's dormant title with the help of the author, manufacture brand new traction engines for preservationists. The engines continue the build number order from where Fosters left off, thus continuing a tradition of engine building in the county into the twenty-first century.

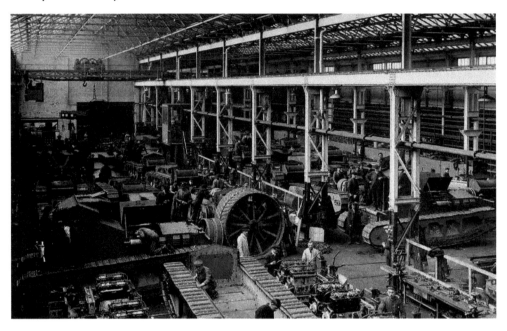

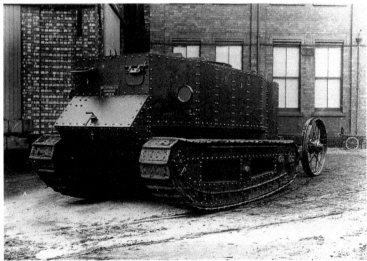

Above: Agricultural engineering is forsaken for building tanks at Fosters in 1918. (Richard Pullen Collection)

Left: Top secret new weapon 'Little Willie' in his final form in Foster's yard. (Richard Pullen Collection)

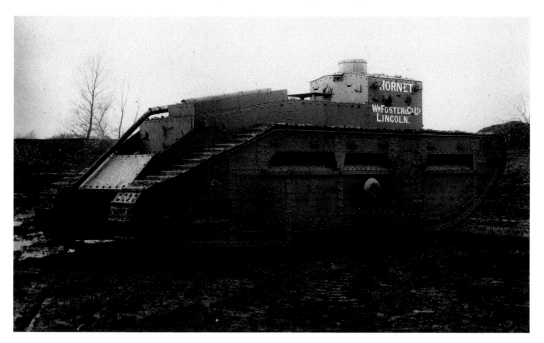

A brand new Medium C Hornet tank on Foster's testing ground, still showing the sign writer's chalk marks. (Richard Pullen Collection)

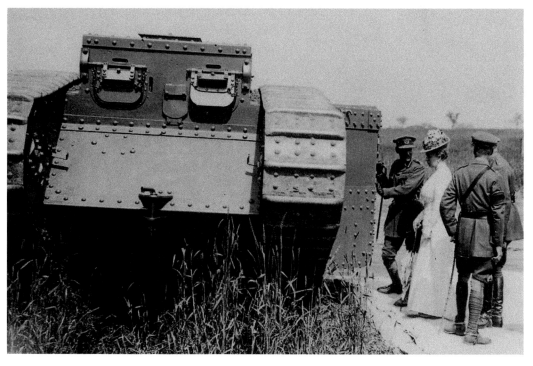

A mk II training tank being inspected by Queen Mary. (Richard Pullen Collection)

Repatriated from Australia where it worked in quarries and a sawmill, the only surviving Foster steam wagon of a total of sixty built. (Simon Colbeck)

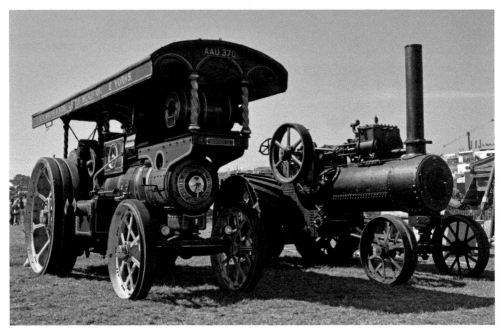

Foster showman's road locomotive of 1934 *Success* contrasts with a Foster Colonial Compound straw-burning engine of 1910, repatriated from South America. (Simon Colbeck)

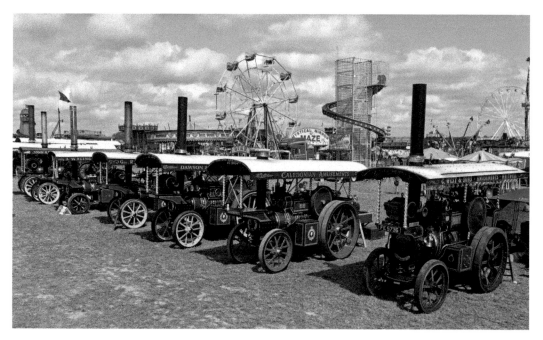

Six of the smaller Foster showman's tractors stand in line at the 2019 Great Dorset Steam Fair. (Simon Colbeck)

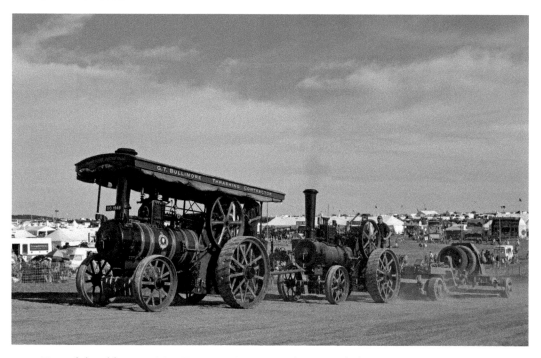

Two of the oldest surviving Foster engines – an 8 hp example from 1896 is seen towing its sister from 1898. (Simon Colbeck)

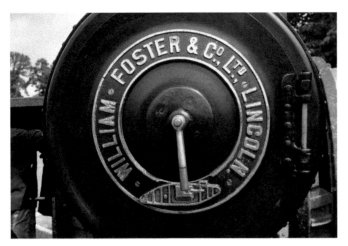

Left: After the war, the Foster tank was incorporated into Foster's smokebox nameplates.

Below: A twenty-first-century-built Foster 7 hp compound traction engine stands completed in 2017, surrounded by the patterns that formed its construction at the revitalised Foster works in Bicker.

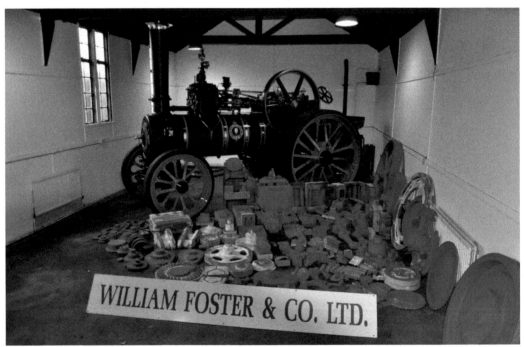

Marshall, Sons & Co. Ltd, Gainsborough

William Marshall had been an apprentice at Fairburn's Manchester factory and was later appointed Fairburn's representative in St Petersburg, the Russian capital at the time. In 1848 he returned to his hometown of Gainsborough and bought a small engineering works in Back Street.

By 1855 the business had outgrown the works and he acquired an initial 1.5 acres of freehold land to build the Britannia Works. Following William's death in 1861 his two sons, James and Henry, took over the business and by the end of the nineteenth century they had established Marshall, Sons & Co. Ltd as one of the leading steam

engine manufacturers in the country. Starting with portable steam engines that could be horse-drawn by contractors from farm to farm, self-moving traction engines followed, along with threshing machines and related agricultural machinery.

Marshalls produced their first oil tractor very early, in 1908, with production running until the First World War, whereupon the workforce and facilities were devoted to the war effort. The return to oil tractors in 1930 created a fresh beginning and its range of single-cylinder machines, crawler track machines and the Field Marshall Series of

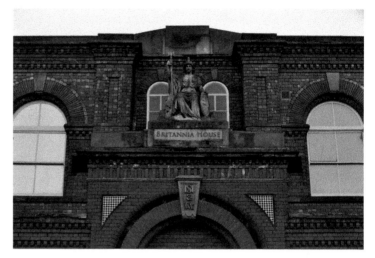

Right: The surviving facade of Marshall's Britannia Works in Gainsborough, with Britannia and 'MS&Co' in the stonework.

Below: Marshall traction engine No. 51007 of 1908 driving a Fosters threshing machine.

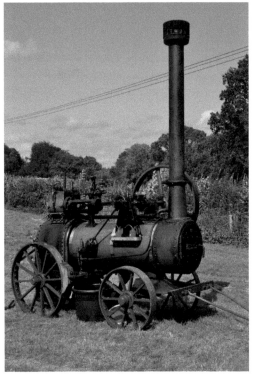

Above: Marshall 10-ton steam roller No. 80608 of 1926 with the Britannia emblem on the headstock.

Left: Marshall portable engines were exported worldwide. No. 53802 of 1909 was repatriated from Italy.

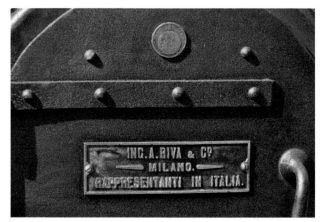

No. 53802 was imported via Marshall's agents Riva & Co. in Milan.

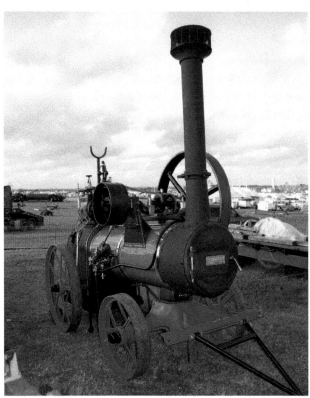

Marshall portable engine No. 70595 of 1910 was repatriated from Australia.

popular tractors were equally world-renowned until a series of unwelcome takeovers in the late 1960s and early 1970s resulted in most of the Marshall workforce being made redundant by the end of 1979.

Part of the facade of the Britannia Works remains along with various converted buildings, and the whole site is now a shopping outlet complex named Marshall's Yard. Once a year, owners of Marshall engines and tractors bring their prized preserved items to the yard for display.

The popular Field Marshall series of tractors were in production at Gainsborough between 1945 and 1957. (Simon Colbeck)

Robey & Co. Ltd, Lincoln

Another Lincoln-based concern that became world famous for its steam engineering. By the middle of the nineteenth century, Robey's Perseverance Works on Canwick Road covered almost 7 acres. The company went from strength to strength and in 1885 the factory was renamed The Globe Works to reflect its worldwide reputation for quality. The company produced a huge array of items including steam wagons, saw benches, threshing machines, traction engines, electrical generators, aircraft, and even the winding gear for Blackpool Tower.

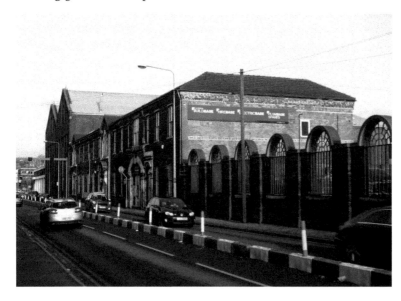

Former buildings and frontage of Robey's Globe Works on Canwick Road, Lincoln, now Jackson's builder's merchants.

Robey managed to cling on for longer than many of its Victorian counterparts, not closing its doors until 1988. Much of the site was cleared and built on, but some of the historic works still survive, including the front offices, having been taken over by Jackson Building Centres.

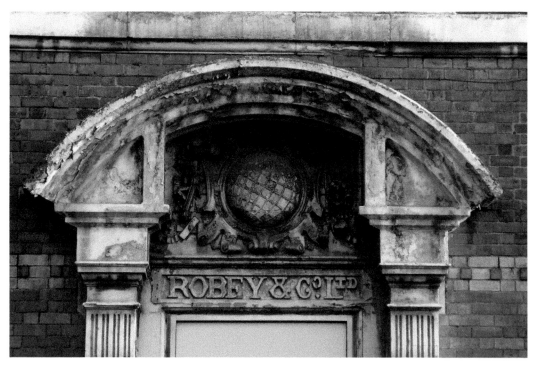

Robey & Co. globe detail above the main doorway.

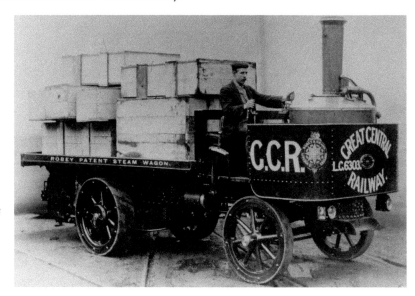

This Robey steam wagon was hired to the Great Central Railway on 12 September 1906. (Old Glory Archive)

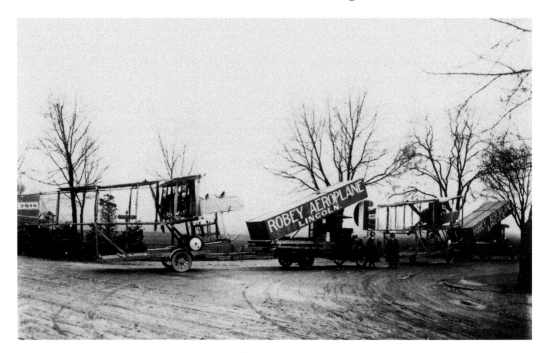

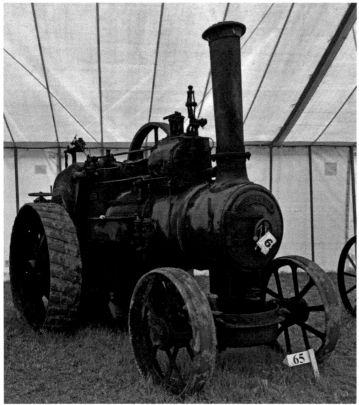

Above: Turning the factory to a wartime footing, Sopwith Gunbus aircraft leave Robey's Globe Works in 1915. (Richard Pullen Collection)

Left: Still in original working clothes is Robey General Purpose Engine No. 29450 of 1910. (Simon Colbeck)

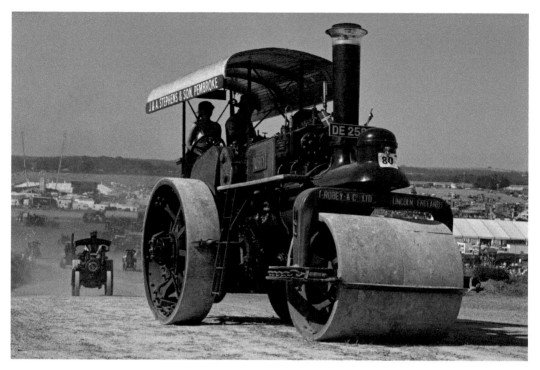

Robey's prototype three-point roller of 1913 shares certain similarities to Marshall rollers. (Simon Colbeck)

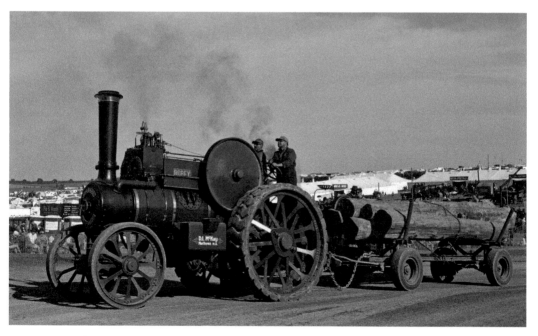

Visiting the UK from New Zealand, Robey road locomotive No. 32701 of 1914. (Simon Colbeck)

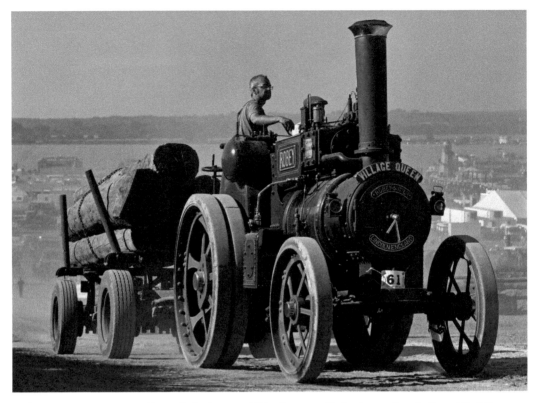

Robey steam tractor No. 33957 of 1915 was exhibited new on Robey's stand at the Royal Dublin Show before being delivered to a paper mill in Tamworth. (Simon Colbeck)

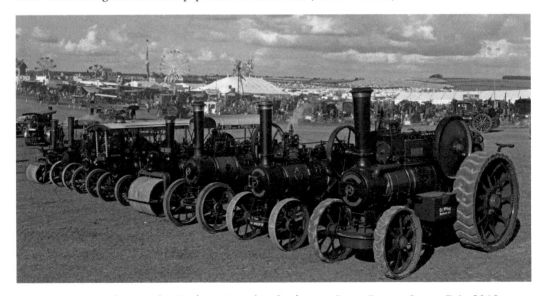

Robey engines in line at the 'Built in Lincoln' display at Great Dorset Steam Fair 2019. (Simon Colbeck)

Ruston, Proctor & Co. Ltd
Ruston & Hornsby Ltd
Ruston-Bucyrus Ltd, Lincoln

Ruston, Proctor & Co. Ltd started as one of Britain's oldest engine-building companies, having started business in Lincoln as general engineers in 1840, under the name of Proctor & Burton.

They became Ruston, Proctor & Co. after 1857, a result of Joseph Ruston joining the firm. At a later date, certainly by 1890, they became a limited company. The firm enjoyed worldwide success in producing portable steam engines for agricultural work and built their first 10 hp road steam traction engine on 6 July 1876.

By 1906 the Sheaf Ironworks in Lincoln extended to 17 acres and employed 2,800 workmen. They also claim to have made and sold 27,000 steam boilers by 1906. The product range was immense – semi-portable engines, undertype fixed engines, centrifugal pumps, winding engines, trench excavators, and an extensive range of agricultural implements.

The firms of Ruston, Proctor & Co. Ltd and Richard Hornsby merged on 11 September 1918 to become Ruston & Hornsby Ltd. 1918 was not a good time for the new company, the market being flooded with surplus army vehicles from the First World War at very low prices.

Petrol and diesel engine lorries had been extensively developed during the war years, a fact that had not escaped the notice of many transport companies who were beginning to appreciate the advantages that these vehicles had over the hitherto conventional steamer.

This, coupled with the fact that the country was heading for the depression, made orders for steam vehicles increasingly difficult to secure during the late 1920s.

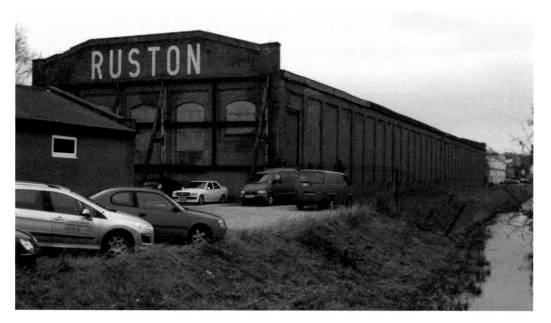

Ruston's former Sheaf Ironworks in Lincoln. Now sadly demolished, the lettering picked out in white bricks were saved for future display elsewhere.

The company did, however, manage to keep their heads above water until the last engine left the works in 1933. Rustons then concentrated on other machinery such as diesel railway locomotives.

Famous for their excavator machines, Ruston-Bucyrus Ltd was founded in 1930, jointly owned by Ruston & Hornsby and Bucyrus-Erie of South Milwaukee, Wisconsin, the latter of which had operational control and absorbed the excavator manufacturing operation of Ruston & Hornsby.

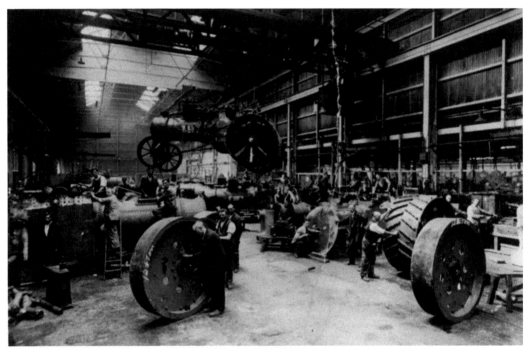

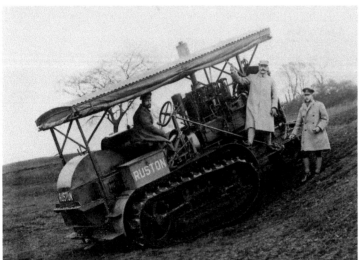

Above: Traction engines being built at Ruston's works, Lincoln. (Old Glory Archive)

Left: Ruston's version of the American Holt tractor, built under licence, being demonstrated to military personnel in Lincoln. (Richard Pullen Collection)

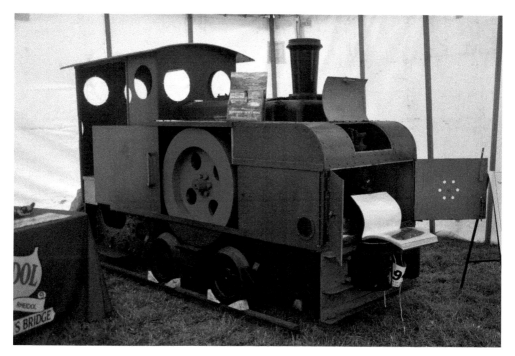

A rare survivor – the first diesel locomotive made by Ruston, Proctor for the First World War in 1917 and representing the transition from steam to diesel, copied from the Germans. Now owned by the Vale of Rheidol Railway.

The very last locomotive built by Ruston & Hornsby in February 1969, new to Nevill's Dock & Railway Co., Llanelli.

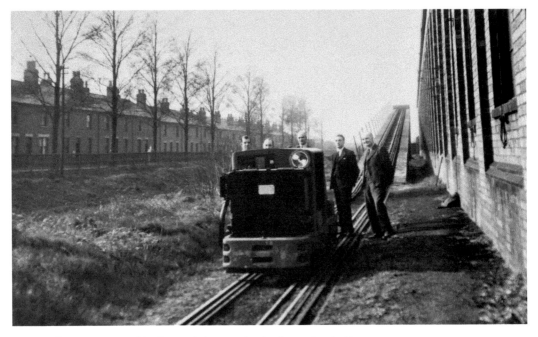

Imagine living opposite this! Ruston's locomotive brake testing incline.

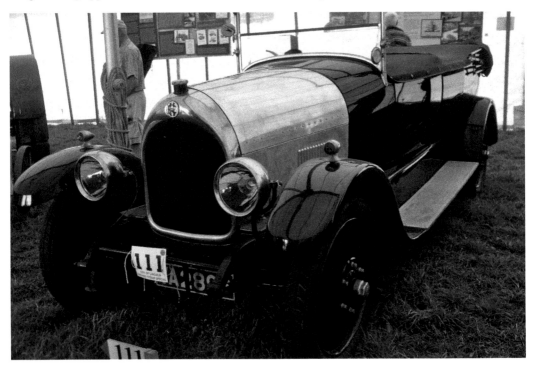

Ruston & Hornsby 20 hp open tourer car, built in 1922.

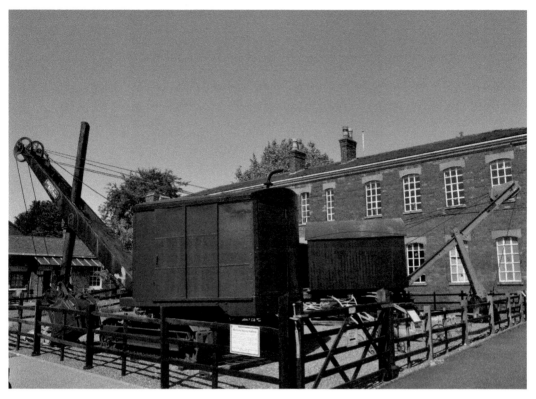

Ruston-Bucyrus excavator, preserved at the Museum of Lincolnshire Life.

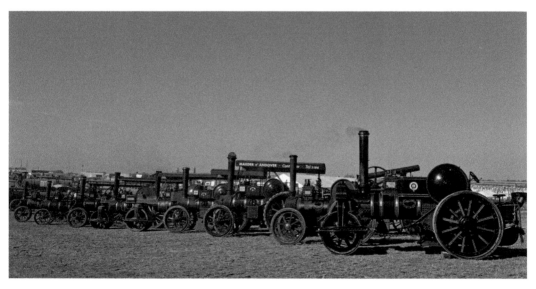

Ruston, Proctor and Ruston & Hornsby engines at the 'Built in Lincoln' display, Great Dorset Steam Fair 2019. (Simon Colbeck)

Wm. Tuxford & Sons, Boston

William Wedd Tuxford was initially a miller and baker, prior to designing and producing a corn screening machine *c.* 1830. This lead to a growing engineering business at the Skirbeck Ironworks in Boston, where Tuxford built his first portable steam engine in 1850, wasting no time in exhibiting an example at the 1851 Great Exhibition. Tuxford also manufactured several beam engines for drainage applications across the Fenland. Tuxford never produced engines in large quantities and ceased trading in 1886. The premises were sold and no trace of the works remain but, amazingly, a total of eight steam portable engines from the 1880s survive in preservation.

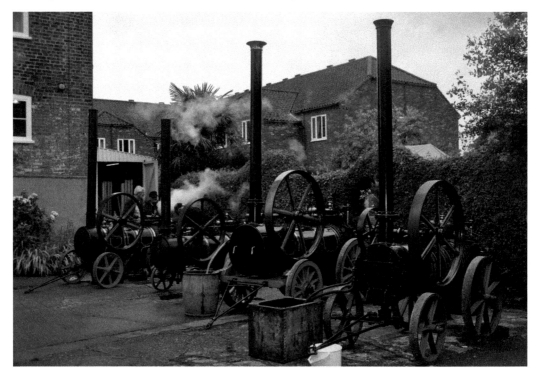

A rare gathering of four Tuxford of Boston portable engines from the 1880s displayed at an anniversary open day at the town's Maud Foster Windmill.

Chapter 2

Brewing and Malting

The brewing of beer is as old as time itself. The addition of malted barley to hot water, then adding hops and fermenting by adding yeast, is a tried and tested formula from a time when beer was safer to drink than the water. The traditional floor malting method held soaked barley that was spread over several germinating floors before being heated to produce the finished malt.

All Saints Brewery, Stamford

All Saints Brewery on All Saints Street was founded in 1816 and was acquired by Melbourn Brothers in 1869, although it is believed that brewing and malting activities

 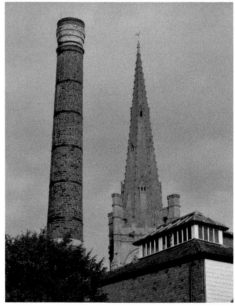

Above left: Melbourn Brothers' All Saints Brewery façade in All Saints Street, Stamford.

Above right: All Saints Brewery chimney compliments the fourteenth-century All Saints Church.

have been carried out on the site for centuries. The old steam brewing equipment is preserved and now used to make the Samuel Smith range of organic handcrafted fruit beers. The former brewery stores is now a Samuel Smith pub. The brewery is temporarily closed to visitors. TF 026071.

Bass Maltings, Sleaford

Surely the largest and most impressive monument still standing to Lincolnshire's industrial past. With the abundance of barley grown in Lincolnshire, a suitable source of water found by boring an artesan well in 1892 and with good railway links to the Midlands, 13 acres of land in Sleaford were purchased by Bass, Ratcliff & Gretton Ltd of Burton-on-Trent. Here in 1899, a series of eight maltings with a central engine house, workshops and staff cottages were constructed to become the largest of its type to have been built in England to the design of Bass chief engineer Herbert Couchman.

A pair of Robey of Lincoln engines were supplied to the maltings and from their central engine house powered hoists, pumps, screens and ventilators. Power was transmitted through the maltings by means of line shafting driven by ropes from the engine's 13-foot flywheels. One of these engines survives in operable condition on public view at the Museum of Brewing in Burton-on-Trent.

The complex ran to full capacity until after the Second World War, then Bass installed more efficient systems at their Burton plant in the 1950s, paving the way for closure in 1959.

Fire damage, first in 1969 and then 1976, saw three blocks damaged internally and the buildings have never been fully occupied since. Grade II listed as representing the pinnacle of floor malting development in England, the site remains derelict despite plenty of talk and failed planning applications. The row of staff cottages on the approach to the site are still habitable, accessed off Mareham Lane near the Carre Arms Hotel. TF 074452.

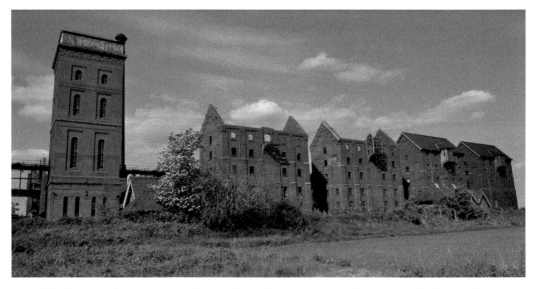

Arguably the most impressive surviving industrial monument in the county, the former Bass Maltings in Sleaford are Grade II listed but remain derelict.

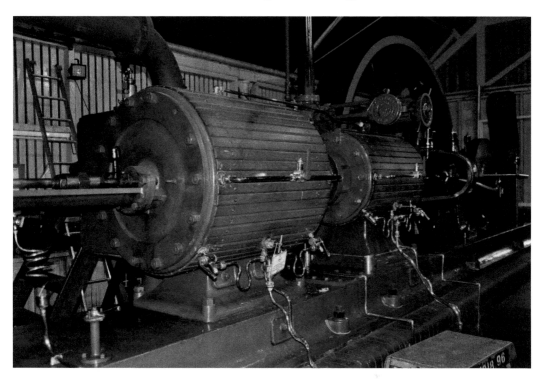

One of a pair of Robey of Lincoln engines supplied in 1905 to the Bass Maltings, built as a mirror image of each other. From their central engine house they powered the hoists, pumps, screens and ventilators until closure in 1959. Preserved and sometimes demonstrated at the Museum of Brewing in Burton-on-Trent.

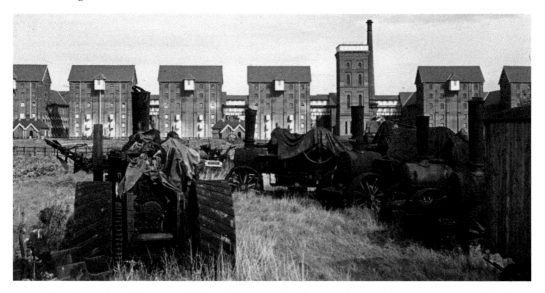

The Sleaford Maltings in all their glory provide the backdrop to this 1962 view of ploughing contractors H. J. Road's yard on Spalding Road. (Mike Swift)

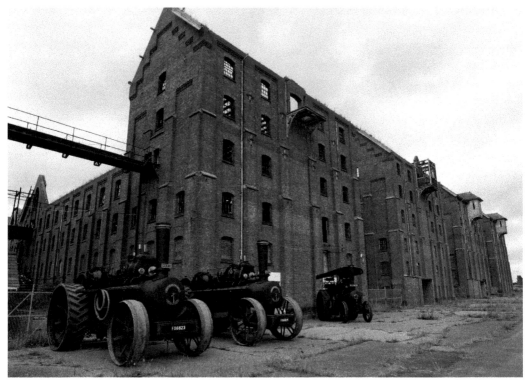

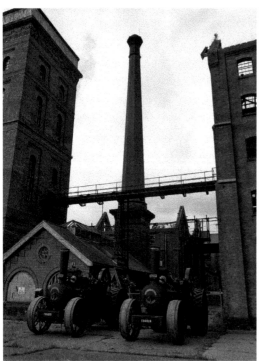

Above: Another Sleaford agricultural firm were cultivating contractors Ward & Dale Ltd of Mareham Lane. Their surviving engines were given permission to return to the maltings in August 2014 to commemorate seventy-five years since their closing down sale of engines. (Paul Cook)

Left: Fowler ploughing engines *Ward* and *Dale* pose at the derelict malting. (Paul Cook)

Batemans Brewery, Wainfleet All Saints

Founded by George Bateman in 1874, the brewing operation is still in the hands of the family's fourth generation and is the oldest continuous brewer in the county. It remains fiercely independent, with a tied estate of fifty pubs. The brewery includes an original tower mill and a visitor centre that is open daily. Tours of the Victorian brewhouse can be pre-booked. TF 495587.

Maltings, Bourne

Brick maltings of the late eighteenth century on West Street, Bourne. Rebuilt extensively by John Dove in 1806 following a serious fire and then extended in the mid-1800s. Now subsumed into the large specialist magazine print works of family-run Warners Midlands plc, established by Lorenzo Warner in the town in 1926. TF 093202.

Sandars Maltings, Gainsborough

Gainsborough was ideally placed between the major Midlands brewing towns and the barley producing counties of Lincolnshire and Norfolk, linked by inland waterways. Maltsters are documented in Gainsborough from 1615 but expansion came in the late eighteenth century.

At Sandars on Bridge Street, floor malting of barley to produce the malt necessary for the brewing of Tetley-Walker's beer was undertaken in a large four-storey brick building, with many later additions and subsequent demolition. The L-shaped survivor of today has been converted to flats. SK 814893.

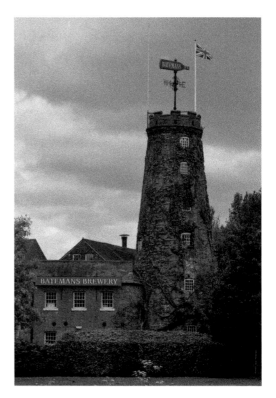

Batemans Brewery at Wainfleet All Saints is the oldest continuous brewer in Lincolnshire, founded in 1874.

The discernable roof line and side hoist reveal the building's original purpose of malting at the modern print works of Warners in Bourne.

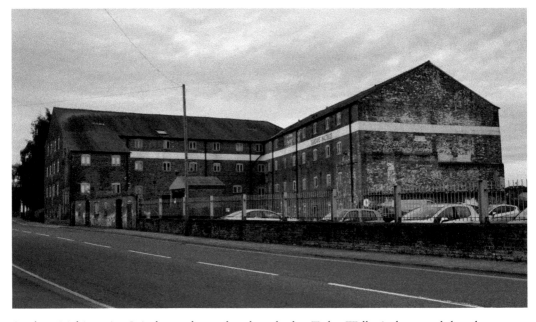

Sandars Maltings in Gainsborough produced malt for Tetley-Walker's beer and has been repurposed to flats.

Chapter 3

Bricks and Tiles, Mines and Quarries

Bricks and Tiles

Aside from brickworks closed around 1907 that were built to serve the growing city of Lincoln, the most productive area in the county for manufacturing bricks and tiles was along the south bank of the River Humber, with several sites both east and west of the 1981-built Humber toll bridge chosen for their large reserves of quality clay. Bricks and tiles would be dispatched inland by water to Yorkshire and via the coast to East Anglia and London. Blyth Brick & Tile at Barton on Humber still produces pantiles while directly to the west of Humber bridge is an area accessible to the public in a garden centre that contains several surviving relics of the brickmaking industry.

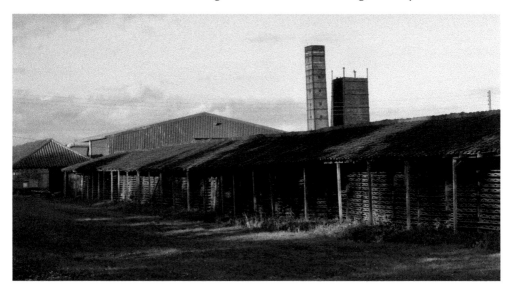

William Blyth's tile works in Barton-upon-Humber are still very much in production with several original buildings and chimneys.

Blyth's drying sheds, still being used for their original purpose.

Blyth still operate from the site at the Old Tile Works, accessed via Far Ings Road just to the west of the Humber bridge, with many structures still preserved.

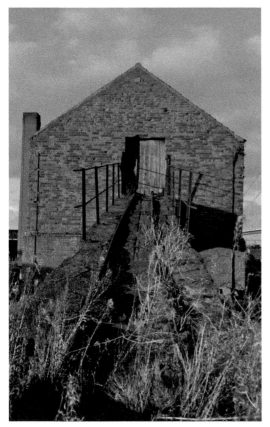

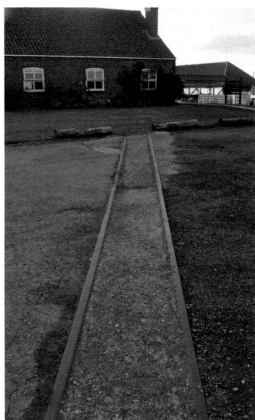

Above left: The disused inclined wagonway.

Above right: Disused rails in the tile yard. This works operated the last surviving brickyard railway in Britain.

A remarkable survivor, this Motor Rail of Bedford 'Simplex' locomotive was new to a Mablethorpe firm, who were strengthening sea defences prior to working Mablethorpe Brick & Tile Works, then in 1970 moved to Skegness Brick & Tile Works, where it is seen at Skegness hauling 'tubs' of clay for making into bricks. (Geoff Hankin)

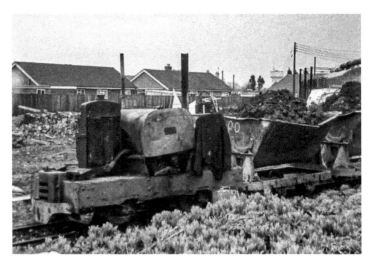

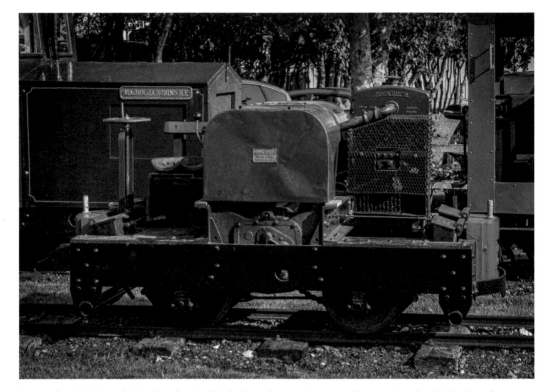

September 2020 and the Simplex is finished and preparing to take part in the Eight Simplex Cavalcade to mark the sixtieth anniversary of the Lincolnshire Coast Light Railway's opening as the world's first heritage line to be built by enthusiasts. (Dave Enefer, LCLR)

Mines and Quarries

It seems hard to believe now but there were once underground mines in Lincolnshire. Nettleton near Caistor boasted two ironstone mines: Nettleton Top Mine (1928–1959) and Nettleton Bottom Mine (1957–1968). Not much to see now except some surviving buildings at Top Mine, while the valley that forms Bottom Mine can be reached from the Viking Way long-distance trail.

Limestone quarrying began at Thistleton, South Witham, in the 1890s when a 60-foot bed was exposed by contractors building the railway from Saxby to Bourne. Instead of extraction via opencast, as was the practice in the East Midlands, it was decided to mine the considerable reserves from 1957, but geological difficulties and seepage led to closure in 1964. Production peaked at 390,000 tons a year rather than the million envisaged and was thus short-lived, as was a sister mine at Easton, Colsterworth, that closed in 1967.

Sand, gravel and stone quarries still trade in the county in some quantity but a good OS map can pick out abandoned chalk quarries and the like. The chalk quarry at Nettleton was opened in 1960 and supplied chalk to Scunthorpe steelworks. It was roaded to Holton le Moor sidings for onward shipment by rail to Scunthorpe until 1970. The quarry is best viewed from Nettleton Top on the Viking Way long-distance trail.

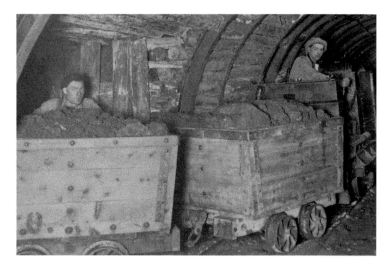

Workers underground at Nettleton Top Mine, which closed in 1959. (Andrew Neale Collection)

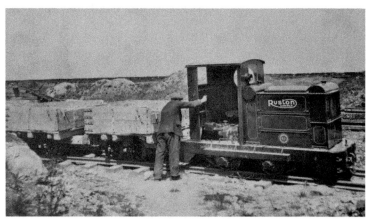

A brand new Ruston of Lincoln 30 hp locomotive, the first of locos delivered to South Witham Limestone Quarry between 1934 and 1937. The wagons are not quite so new! (Andrew Neale Collection)

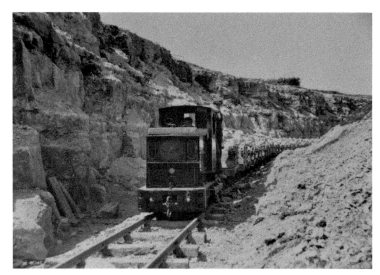

A loaded wagon train of limestone at South Witham. (Andrew Neale Collection)

Chapter 4

Iron and Steel

Ironworks

Iron foundries could once be found in Boston, Lincoln, Gainsborough, Grantham, Horncastle and New Bolingbroke – many of them evolving into full engineering facilities for agricultural engineering. Rundles of New Bolingbroke were the last to close their foundry but remain agricultural and fairground engineers.

Now housing an antiques premises on The Wong in Horncastle, this building was part of William Ashton's Hopton Ironworks of 1873. One block to the east is Foundry Street, once home to Thomas Tupholme's Union Foundry – although the buildings have been much altered over the years.

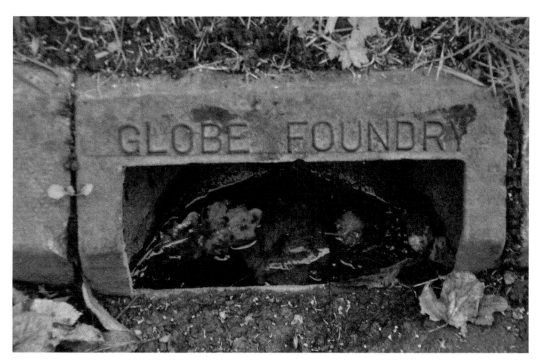

Over 30,000 kerbside drain soakaways were manufactured by Rundle at their Globe foundry. Many are still in situ, including these two that read 'Globe Foundry' and 'John H Rundle Ltd'.

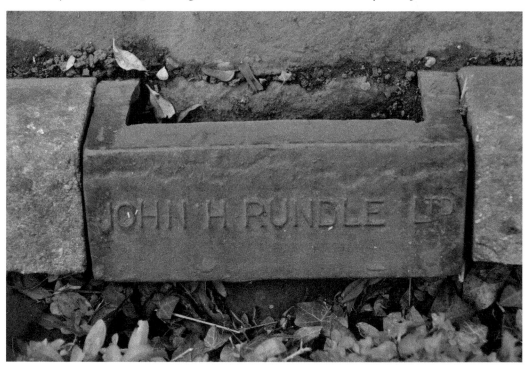

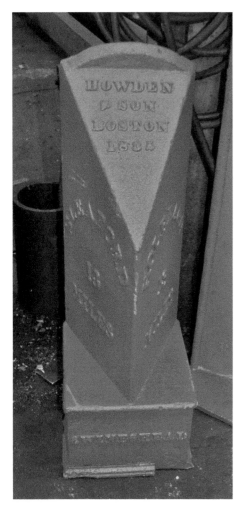 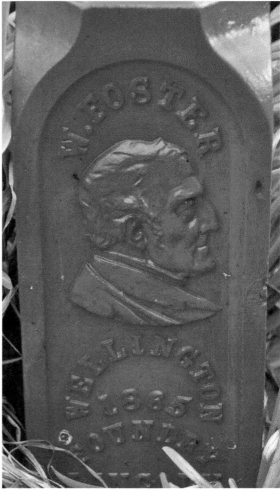

Above left: In for repair is this iron milepost from Swineshead, originally cast by Howden & Son of Boston in 1835 and measuring 15 miles to both Sleaford and Holbeach.

Above right: Foster's of Lincoln also cast lamp posts for the city of Lincoln. They featured William Foster's caricature and the legend 'W. Foster, Wellington Foundry, Lincoln, 1865'.

Steelworks

The steelworks at Scunthorpe was established in the mid-nineteenth century, initially exporting iron ore for iron producers before the industry consolidated in the early 1900s with three separate site ownerships that became part of the nationalised British Steel Corporation in 1967. Following privatisation in 1988 there have been several owners, but Scunthorpe is still a primary iron and steel producing site of some 12 miles in area. It is possible to get closer to the workings of the site by booking a rail tour on the Appleby Frodingham Railway, running since 1990 on selected weekends between May and October. Driver experiences (steam or diesel) are also available. (www.afrps.co.uk)

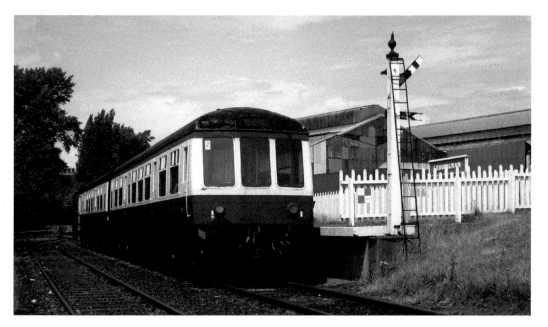

An Ex-BR Class 108 DMU of 1958 vintage awaits its passengers at Frodingham station for a tour round the Scunthorpe Steelworks. (Phil Barnes)

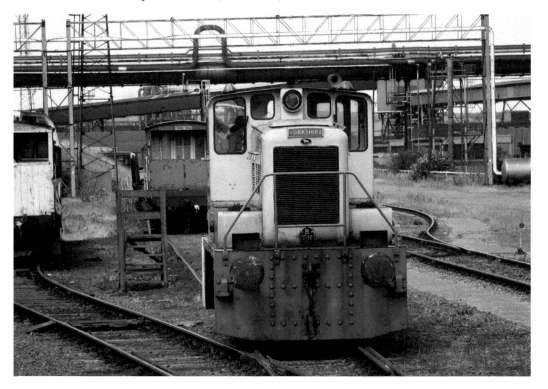

Yorkshire Engine Company 0-6-0DE loco No. 1 *Janus* giving cab rides near the depot. (Phil Barnes)

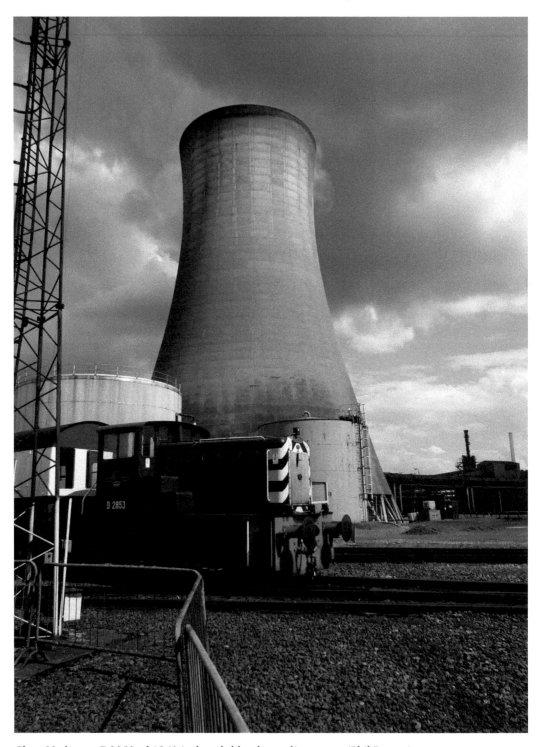

Class 02 shunter D2853 of 1960 is dwarfed by the cooling tower. (Phil Barnes)

Chapter 5

Paper, Peat and Potatoes

Paper

It is well known that the Chinese 'invented' paper around AD 100, using rags and rice stalks, and the process came to Europe in the twelfth century. The first recorded paper mill in England was on a tributary of the River Lea above Hertford and the earliest record of papermakers in Lincolnshire is at Leasingham Moor near Sleaford, which continued to produce paper until 1829. Next came Tealby Mill (1700–1829); Houghton (Grantham) (1731–1890); West Deeping (1733–1745); a second mill at Tealby (1763–1834); Barrow on Humber (1780–1800); Louth (1794–1843); and a third mill at Tealby (1800–1829).

White cotton or linen rags (originally imported from Europe) were cut, agitated, pressed, dried and rolled. The main ingredient for successful papermaking was a reliable source of clean water that contained no iron deposits that would cause staining, hence the mills being sited next to rivers and using power derived from a waterwheel.

West Deeping Paper Mill

Situated over a tributary of the River Welland, this former mill is an attractive two-storey building of local Barnack stone. It ceased producing paper in 1745. Now a private residence, it can be viewed from the road adjacent to St Andrew's parish church. TF 108086.

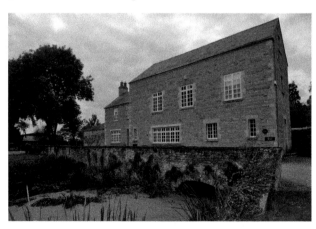

Now a fine private residence, the former stone built paper mill at West Deeping.

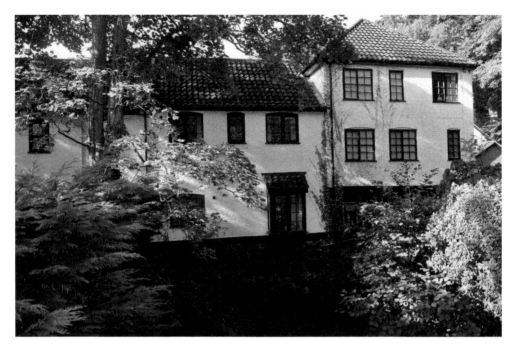

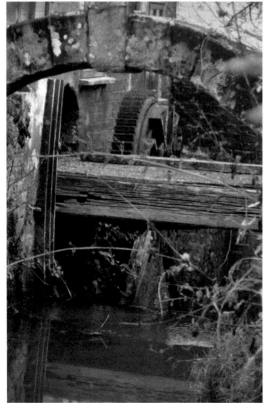

Above: Westgate Paper Mill, Louth, operational from the 1780s to the 1840s prior to reverting to corn milling.

Left: The cast iron waterwheel at Westgate survives in its wheel pit at the rear of the property.

Westgate Paper Mill, Louth
Also known as Thorpe Hall Mill, a substantial white painted brick structure used as a paper mill from the 1780s to the 1840s, it reverted to corn milling *c.* 1844 until 1920, and was much later used as a trout farm. Its cast iron waterwheel survives in its wheel pit and can be seen at the rear of the property, which is now a private dwelling. Viewed from Westgate. TF 321873.

Peat

Peat cutting has been a staple industry on the Isle of Axholme going back to medieval times. Cut by hand, the worker utilised a long thin blade that cut the peat into brick-sized slabs called Turves. One man could cut 1,000 Turves a day and a modest cottage of the time would have required 8,000 Turves to heat it for a year.

The Crowle Peatland Railway opened its doors to the public for the first time in September 2019 to showcase the impressive efforts made so far to preserve the former peat workings and their associated narrow gauge railways.

Founded in 2014, the group is part of the Isle of Axholme and Hatfield Chase Landscape Partnership. Thanks to strong support from North Lincolnshire Council and the National Lottery a new steel running shed and museum building to house the railway collection has been erected, which can house all the railway's current locomotives and stock. The stock came from the 3-foot gauge systems at Hatfield and Swinefleet Moors just over the county border in South Yorkshire, and comprises three German Schoma 'master and slave' locomotives, one original peat wagon, and two peat wagon underframes.

The first part of the line has been laid by society members using 35 lb-per-yard rail from the former Eastriggs ordnance depot. The society also own a fourth locomotive from the former peat works fleet. This is a 40S series Motor Rail diesel locomotive new to Fisons Ltd in 1967, which was left abandoned on the moors for some years after closure of the railway. In 2015 it was recovered by society members in a vandalised state but is now being rebuilt by engineering students at North Lindsey College, Scunthorpe.

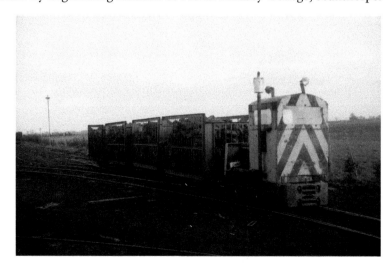

Shunting wagons of cut peat in working days. (Andrew Neale Collection)

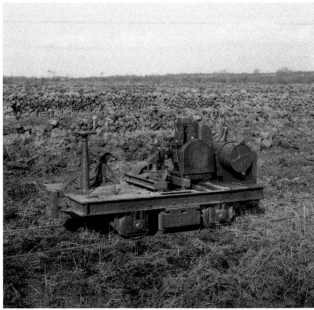

Above left: Wagon tippler on Fison's Swinefleet line shown in operation. (Andrew Neale Collection)

Above right: A Lister petrol loco out on the moor with cut peat stacked behind. (Andrew Neale Collection)

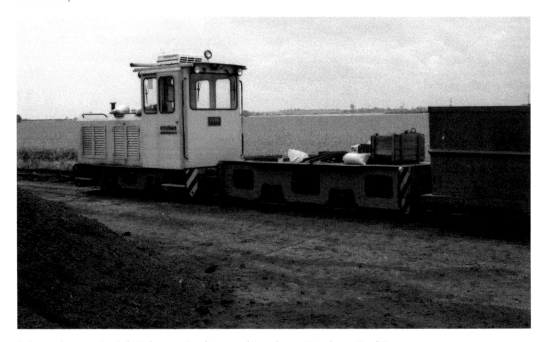

Schoma locomotive *The Thomas Buck* in working days... (Andrew Neale)

Horse-worked tramways of 3-foot gauge were used since the 1890s to haul peat to the mills until after the Second World War, when lightweight diesel locomotives were used.

The railway's ultimate aim is to extend their line on to Crowle Moors, but to achieve this they will need to build suitable passenger stock and acquire more rail, particularly turnouts. However, having made such impressive progress in a relatively short time, all this should be achievable within a reasonable period.

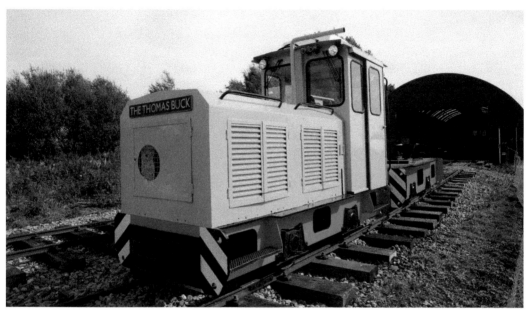

...and now preserved at the nascent Crowle Peatland Railway. (Andrew Neale)

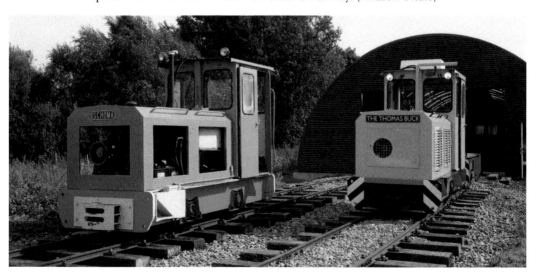

The two locomotives stand proudly outside their new steel running shed and museum at Crowle, built with support from North Lincolnshire Council and the National Lottery. (Andrew Neale)

Potatoes

The dark loamy soil of reclaimed Lincolnshire Fenland have long been used for arable crops and today grain, sugar beet, vegetables, salad crops, bulbs and soft fruit are grown almost exclusively, but it is to the humble potato that was grown on an industrial scale in the county. By the end of the nineteenth century disease in potatoes had been eradicated and methods of cultivation had improved. Growing competition in the grain markets worldwide led to Lincolnshire farmers looking for alternative crops, helped by the Great Northern Railway among others, who encouraged farmers to use the advantages of the railway to take crops to market.

Some entrepreneurial farmers became very rich, such as the Caudwell and Dennis families who had huge reserves of land, and by the time of the First World War farms of 1,000 acres were not uncommon.

At the end of the First World War there was a large amount of surplus narrow gauge track and equipment that supplied the French trenches, and farmers large and small built railways on their land to bring crops in outlying fields to a staging or transfer point near to a road or standard gauge railway for transhipment, initially using horse power and later small petrol locomotives. In Lincolnshire there were over 140 miles of track in fifty different locations – mainly on fenland in the south of the county, south of Lincoln at Nocton and on the Isle of Axholme in the north. Most of the lines lasted until the Second World War but the loss of skilled workers to the armed forces, coupled with increasing use of mechanisation after the war, saw an inevitable decline in the use of railways. In 1945 there was only twenty-four locations with railways, and only five remained after the end of 1950 with some hanging on until the 1960s.

The largest and longest-lived railway was the 2-foot gauge system on the Nocton estate, owned by W. Dennis & Son, who established their estate of 7,800 acres in 1919

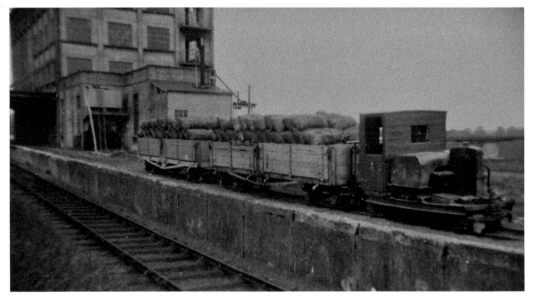

Sacks of potatoes at Nocton Exchange Siding *c.* 1954 with a 1920 Motor Rail petrol loco and ex-War Department bogie wagons. (Andrew Neale Collection)

with the centre of operations adjacent to the main line between Sleaford and Lincoln. The estate's main customers were Smith's Potato Crisps, which had a factory in Lincoln, and they bought the land in 1936.

Aside from the odd fenland farm fence post cut from redundant rail, there is little on the ground to remind us of this huge industry. Happily, much rail and several items of rolling stock have survived and it is thus possible to get a feel of what these lines must have been like by travelling on the narrow gauge line at North Ings Farm Museum in Dorrington near Sleaford (open the first Sunday of each month from April to October) and the Lincolnshire Coast Light Railway at Skegness Water Park.

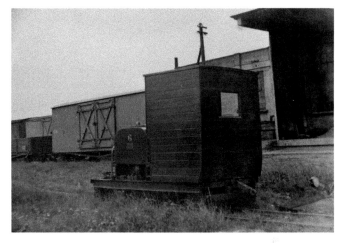

Loco No. 6 at Nocton on 25 July 1951 with an ex-Army Ambulance Van behind, used as a workshop. The Ambulance Van survives at the Lincs Coast Light Railway. (Andrew Neale Collection)

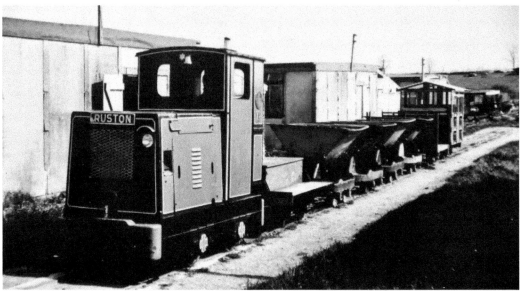

Upon closure of the potato lines, much stock and rail went to North Ings Farm at Dorrington, where the rebuilt 2-foot gauge railway was used to transport chicken feed to an egg production unit between 1972 and 1982, seen here in August 1982. (Andrew Neale Collection)

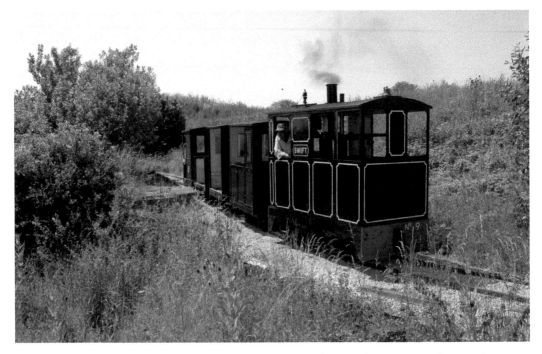

The atmosphere of a former potato railway can be experienced at North Ings Farm, where resident steam locomotive *Swift* takes visitors in carriages from the former Abbey Light Railway in Leeds.

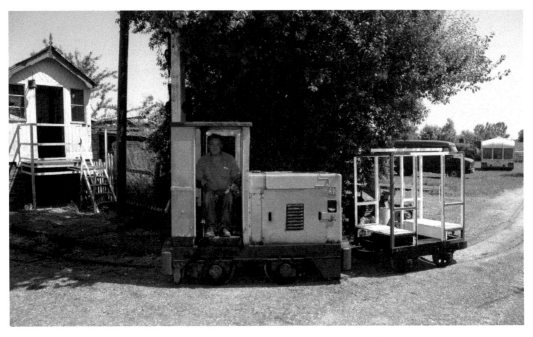

The author takes control of a Ruston & Hornsby locomotive at North Ings in 2005. (Brian Sharpe)

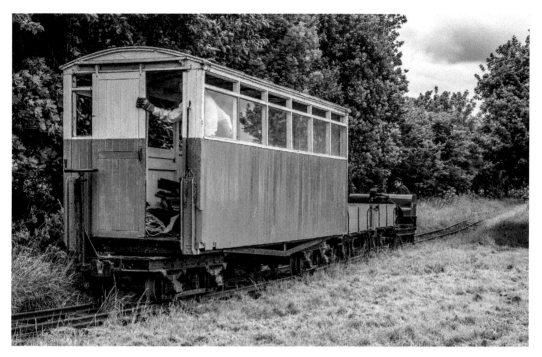

A former Nocton potato railway coach survives at the Lincs Coast Light Railway at Skegness, used on the Nocton estate for shooting parties and currently being converted to carry passengers.

A simple turntable arrangement for a wagon loading point.

Materials can be carried easily around the farm by rail.

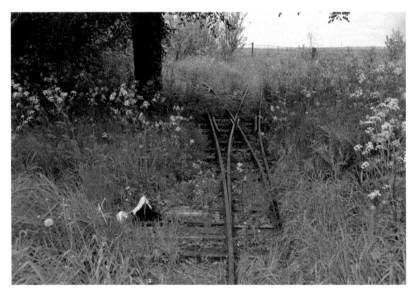

The essence of a potato railway on a private farm in the Lincolnshire Wolds. Track would simply be laid to outlying fields when required.

Chapter 6

Public Utilities and Pumping Stations

Gas
Gas Works Office, Stamford
The first gas works in Lincolnshire came to the town of Stamford in 1826. The two-storey red-brick works office still stands on the corner of Wharf Road and Gas Street and can be viewed from the adjacent car park. TF 033071.

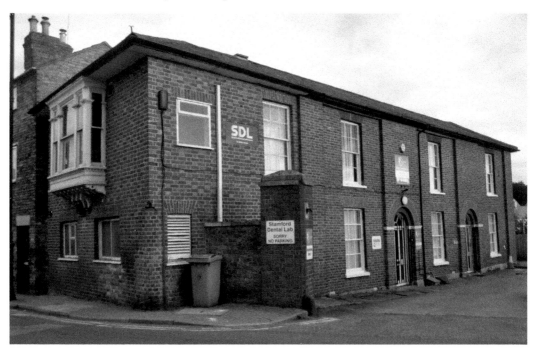

The first gas works in Lincolnshire was at Stamford. The 1826 works office survives in Gas Street/Wharf Road.

Water

In the days before piped water supplies, particularly in rural areas, the village pump was the only place to collect water other than uncontrolled natural springs. Private wells in gardens were the preserve of the well-healed. While there are several examples of surviving redundant hand pumps in the county, we have chosen to illustrate the fine example in the Market Place at Kirton in Lindsey, believed to have been installed during 1792. It was one of four known public water supply points in the area. The village did not receive piped mains water until 1939, mainly due to an RAF base being built nearby.

Bardney Water Tower

Still standing proud in a field to the north-west of the village, a 38-foot-tall red-brick tower with its 8-foot iron tank still extant was built *c.* 1903 and supplied the village's water until 1938, fed from local bore holes. Post-1938 a new piped mains water supply was pumped from Welton. TF 115703.

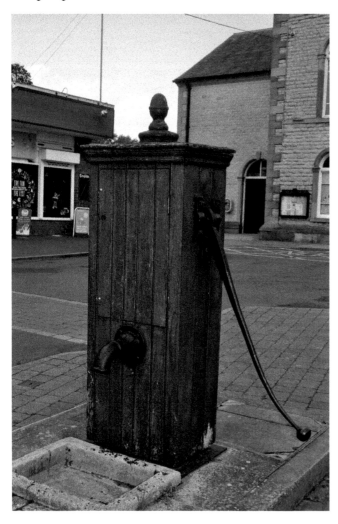

Kirton in Lindsey did not receive mains piped water until 1939. This surviving hand pump is one of four that supplied villagers with water.

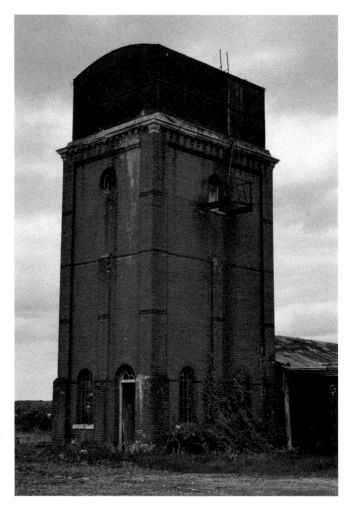

Several water towers survive in the county. This example is at Bardney, built *c*. 1903, and supplied the village's water from local bore holes until 1938.

Pumping Stations

Pumping stations for fenland drainage were very much utilitarian in their construction, not for Lincolnshire the fine Victorian water treatment pumping stations built by proud metropolitan and town councils. They stand as a monument to our ancestors who first wrestled with the flooding from the rivers and sea, embanking and erecting sluices to contain and direct the waters, and then lifting flood waters by wind-driven and eventually steam-driven pumps into the rivers. Such work enabled a living to be obtained from land that otherwise would be marsh and bog.

Vast areas of neighbouring upland can only discharge their water through the fens and, without a drainage system, would become trapped. The soil of the fens was formed following the end of the last Ice Age, which caused a major rise in sea level that inundated the land, followed by a series of mild periods and inundations. This created alternate layers of peat and silt (see section on peat), peat being dominant on the Isle of Axholme with silt predominating in South Lincolnshire. Silt does not shrink like peat when drying out but gradually compacts and wasted, meaning pumping becomes necessary.

The general drainage enterprises of the seventeenth and eighteenth centuries relied on gravity to discharge waters ultimately into The Wash but wastage of the soil soon led to this method being inadequate. Wind pumps were then applied to lift water from the land into the rivers, but were useless after a flood when there was no wind and were prone to catching fire or being blown over. Thus the industrial age saw the advent of steam machinery, then internal combustion engines and nowadays electric power. Without continual pumping, the fens would rapidly return to their water-logged state.

Anderby Drainage Engine Museum

Situated at the seaward side of the Anderby Drain at Gowts Bridge near Skegness, this diesel-powered red-brick pumping station built in 1945 served the area well for fifty years and was preserved by the Alford Drainage Board when the new electrical powered pumping station adjacent to it was opened in 1992. It houses two Ruston of Lincoln 10HRC twin-cylinder oil engines that drive Allen Gwynnes 42-inch centrifugal pumps. An adjacent display room houses land drainage equipment and items recovered from the marsh including labourer's clay pipes and even a human skull! Very limited public opening, visit https://wmc-idbs.org.uk/about-us/heritage/ for information. TF 546759.

Dogdyke Pumping Station, Tattershall

Fen drainage began here in 1796 with a wind-driven pump to drain a large area of farmland between the rivers Bain and Witham. It was replaced in 1856 by steam with an external condensing beam engine made by Bradley & Craven of Wakefield. The 16 hp engine drove a 24-foot-diameter scoop wheel with wooden floats, lifting 25 tons of water from the lower drain into the River Witham, although the water is now channelled back into the drain. It is now the only surviving engine by this manufacturer and is believed to be the oldest steam-driven scoop wheel drainage pumping set in the UK that still steams and is in its original position.

In 1940 a new building was erected to house a 40 hp Ruston & Hornsby of Lincoln 7XHR single-cylinder diesel engine, driving a 22-inch Gwynnes centrifugal pump. The whole was replaced by electric pumps by the drainage board on a different site in 1979, but the vintage kit can be used in an emergency.

Maintained by volunteers, the site holds frequent open days on the first Sunday of the month, see www.dogdyke.com for information. TF 206558.

Gayton Engine Pumping Station

Built in 1850 to pump water from the Gayton Fen and the surrounding marsh into the River Great Eau, the white-painted brick structure boasts some splendid Victorian arched windows. The pump was powered by a steam engine until a reconditioned ex-marine Petter 'Atomic' two-stroke diesel engine of 1936 was installed in 1945. This was later replaced by a new electric pump situated along the river closer to the sea, although the diesel engine remained on standby for a short period while the efficiency of the new pumps was tested. The Petter engine powers a 27-inch Gwynnes pump. It's open to visitors once a month between May and September, when the diesel engine and pump are made operable. TF 457873.

Lade Bank Pumping Station, Old Leake

An impressive Grade II listed red and yellow brick Victorian building and 90-foot-tall chimney of 1867, built on the site of Lade Bank Lock in 1805. It was situated on the 14-mile-long navigable Hobhole Drain and built to counteract the effects of the shrinking of the peat in the East Fen, which could no longer be drained by gravity alone.

Two pairs of high-pressure condensing engines worked two centrifugal pumps with steam supplied from six Cornish boilers, supplied and installed by Easton Amos & Sons. These were replaced with diesel pumps installed in 1940, following a rebuild alongside the earlier building in 1938. The remains of Lade Bank Lock can be seen alongside and the whole site can be viewed from the road on the west bank of Hobhole Drain. TF 379546.

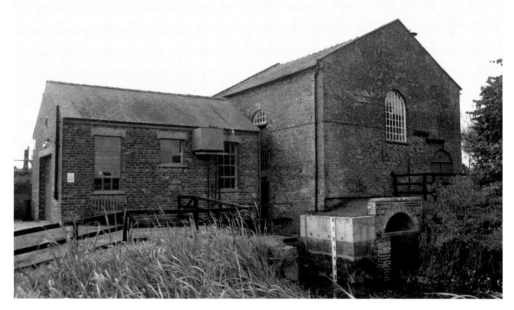

Above: Dogdyke Pumping Station at Tattershall houses the oldest steam-driven scoop wheel drainage pumping set in the UK and holds frequent open days on the first Sunday of the month.

Right: The 40 hp Ruston & Hornsby of Lincoln 7XHR single-cylinder diesel engine at Dogdyke was installed in 1940.

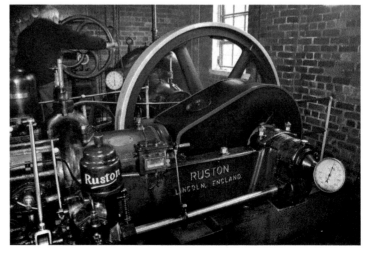

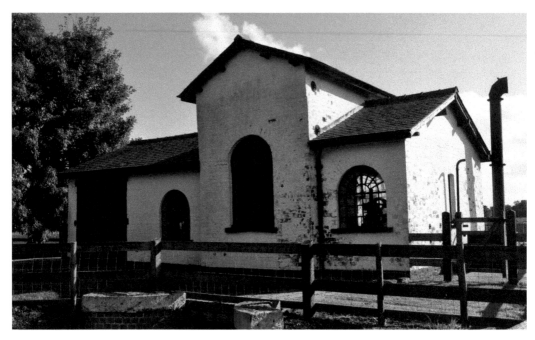

Open to visitors once a month Gayton Engine Pumping Station was built in 1850 to pump water from Gayton Fen and the surrounding marshland.

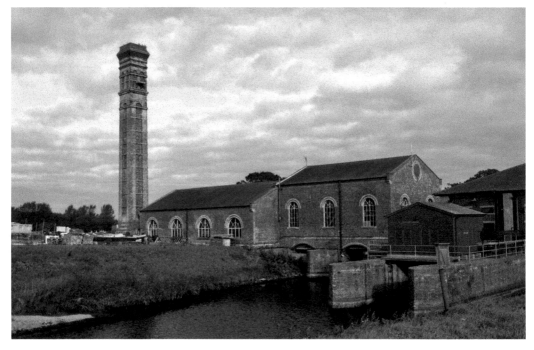

Built in 1805 to counteract the effects of the shrinking of the peat in the fen, Lade Bank Pumping Station at Old Leake is an impressive building with its surviving 90-foot chimney.

Owston Ferry Pumping Station

This pumping station was erected in 1910 to manage water levels in the Snow Sewer and Ferry Drain on the Isle of Axholme, which, depending on the state of the tide in the River Trent, could be below the Trent's level and thus require assistance to lift water into it. The preservation society that now cares for the building and the engines within was formed in 2007 and hosts occasional open days.

The original installation consisted of two large Cornish boilers and machinery comprised two Marshall LT Class horizontal compound tandem steam engines, built down the road in Gainsborough. These drove Drysdale centrifugal pumps, built in Glasgow. In 1952 one of the Marshall engines was removed and replaced by the present Ruston & Hornsby 8HRC Class diesel engine, operating at 290 rpm. By 1963 the boilers were beyond economic repair (and probably still are) and an annexe was erected to house a three-cylinder vertical Lister Blackstone EV3 oil engine, and the Ruston engine remained as a secondary pump. Steam has now been restored to Owston Ferry via a refurbished boiler housed in an external container. SK 813995.

Pinchbeck Engine Museum

A red-brick pumping station built in 1833 to house a 20 hp A-frame low-pressure condensing beam engine made by the Butterley Company and is the oldest such engine in situ. It drove a 22-foot diameter scoop wheel drainage engine, the last such example to work in the fens. Each year the engine lifted 3,000,000 tons of water from Pinchbeck Marsh at a rate of 7,500 gallons per minute. Still owned by The Welland & Deepings Internal Drainage Board, it ceased operating in 1952, with the drain diverted to a new electric-powered station. Access from the A16 north of Spalding, although it is not open to visitors at the time of publication. TF 262262.

Pode Hole Pumping Station

A Grade II listed red-brick structure of 1825 with later additions. The original pumping engine was scrapped in 1952 and the modern plant is now operational. Note the original large board of Drainage Board Byelaws on the front of the building, located 2 miles west of Spalding. In the spring of 2021 the drainage pumps ran day and night for nearly a month due to excessive rainfall in the district. Occasional public open days. TF 213220.

Stixwould Pumping Station

A relatively modern installation of the 1930s, this pumping station can be viewed from the Viking Way long-distance trail, near the disused Stixwould railway station, now a private house. Both are on the east bank of the River Witham, a mile south of the village at the end of Station Road. The building still contains its original Ruston diesel engine pumps in working order, although only now used as a back-up for modern electric pumps. TF 158652.

Other interesting pumping stations can be viewed from the road at **Timberland,** a mile north of Tattershall Bridge on the west bank of the Witham, that at one time housed a local Tuxford of Boston high pressure engine (TF 189583) and the utilitarian 1860s building at **Morton Fen,** 3 miles east of Morton, near Bourne (TF 153246).

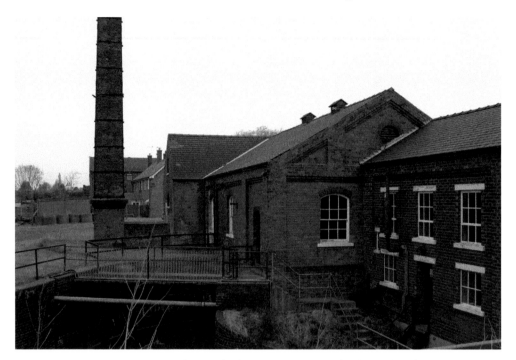

Owston Ferry Pumping Station of 1910, built to manage water levels on the Isle of Axholme, is now in the care of a preservation society, founded in 2007.

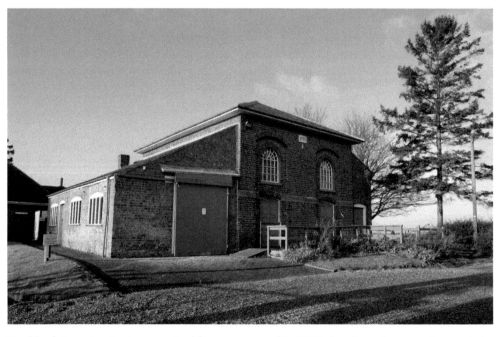

Pinchbeck Pumping Station near Spalding was opened in 1833, housing a beam engine made by the Butterley Company and is the oldest such engine in situ. (Darren Hendley)

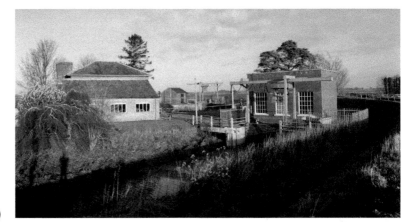

The drain at Pinchbeck was diverted to an adjacent electric-powered station in 1952. (Darren Hendley)

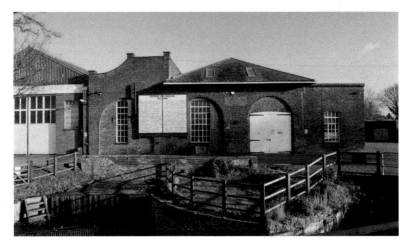

The Grade II listed Pode Hole Pumping Station is of 1825 construction with later additions. (Darren Hendley)

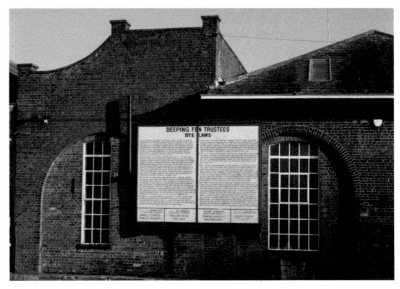

Deeping Fen trustee bylaws notice of 1826 at Pode Hole. (Darren Hendley)

Gainsborough Oil Pumps

Adjacent to Gainsborough Central station is the strange sight (for Lincolnshire!) of a couple of Texas-style 'nodding donkey' oil pumps.

The Gainsborough and Beckingham oil field is one of the largest oil fields in the East Midlands, covering an area of over 13 square kilometres. A significant part of the fields lie around 1,400 metres beneath Gainsborough and the River Trent. The resource was discovered in Gainsborough in 1959 and in Beckingham in 1964.

Gainsborough is home to Britain's first deviated wells, which were constructed to tap oil resources lying directly below the town and the river, and in 1969 this was the most productive single oil field in Britain. Over the years the field has been operated by various companies. Today iGas is operating the field.

With the rail terminal at Beckingham no long in use, all oil goes by road and pipeline to the Conoco Phillips refinery at Immingham. SK 819898.

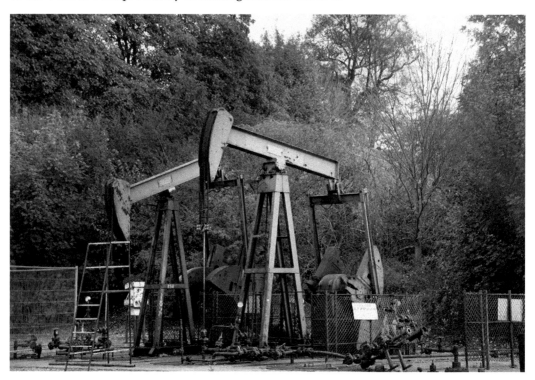

'Nodding Donkey' oil pumps make a strange sight for passengers alighting at the adjacent Gainsborough Central station. (Barry Coward)

Chapter 7

Warehouses and Works

The county can boast many surviving former warehouses and works buildings, most of which have been converted into flats and apartments. Much of the former industrial working waterfronts, for instance along the River Trent at Gainsborough and along The Haven on the River Witham in Boston, can give a flavour of a busier commercial past and make for pleasant walks in the twenty-first century.

Britannia Oil Mill, Boston
A red-brick five-storey oil seed crushing mill built *c.* 1850, situated on Packhorse Quay at its junction with Spain Lane. Later used as a seed store and happily survives after being converted to flats in the 1990s and given the unimaginative name of Pilgrim Mansions. TF 328439.

Brownlow Carriage Works, Grantham
The red-brick showroom of Richard Boyall's Brownlow Carriage, Harness & Steam Wheel works of the late 1800s survives as the customer service point of Jewson's builders merchant on Wharf Road. Boyall manufactured a range of horse-drawn vehicles. The building can be viewed during normal business hours. SK 912353.

Church Mill, Market Rasen
Situated on George Street, this brick five-storey mill of *c.* 1830 was built as a warehouse to serve a proposed canal, a scheme that was abandoned by the arrival of the railway through the town. Converted to a mill, an undershot waterwheel was later replaced by a turbine. It has now been converted to flats. TF 107894.

Crown Mill, Lincoln
A steam corn mill of the 1820s incorporating a four-storey mill and an adjacent nine-storey tower mill, the second tallest in Lincolnshire. The sails were removed in the 1860s when a beam engine was installed. It can be viewed from either Mill Lane or Princess Street via the high street, to the south of the city centre. Now private apartments, but a B&B is available at the top of the tower mill with commanding views of the city. SK 970703.

Left: Among the several old quayside buildings from an era when boats came right into the town is Britannia Oil Mill, an oil seed crushing mill *c.* 1850 now converted to flats.

Below: The showroom of Richard Boyall's Brownlow Carriage, Harness and Steam Wheel works in Grantham is now part of Jewson's builders merchant. (Darren Hendley)

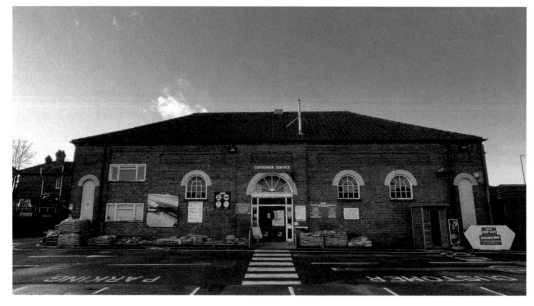

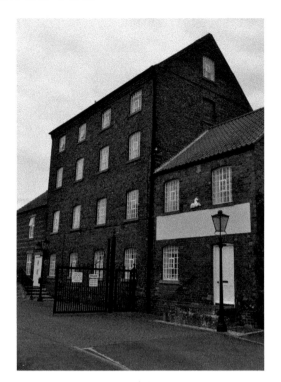

Right: Church Mill on George Street, Market Rasen, was built as a warehouse to serve a proposed canal that was never built, later converted to a mill and now flats.

Below: The four-storey Crown Mill in Lincoln and its nine-storey tower mill, the second tallest in Lincolnshire.

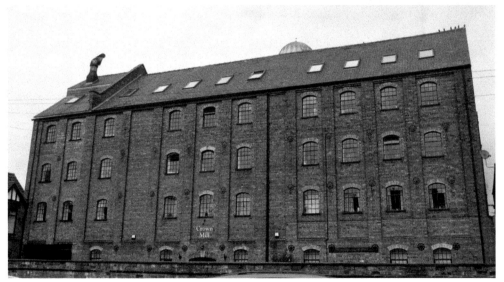

Feather Factory, Boston

The last surviving remnant of a once-proud Lincolnshire industry, the factory on Trinity Street was built in 1877 for Anderson & Co. for purifying feathers for pillow cases and mattresses. This impressive building has now been converted to flats. Note the huge swan statue at the centre top of the façade. TF 323440.

Harrison's Grain Store, Horncastle

Harrison & Sons' nineteenth-century three-storey brick grain store was in close proximity to the town's railway station, which closed in the 1970s and has since been demolished. While the yard is occupied, the building and its wooden canopy are now in a derelict state. TF 255694.

Lincoln's Warehouse, Boston

Situated on Packhorse Quay, of eighteenth-century and nineteenth-century origins and owned by T. H. Lincoln & Son, this Grade II listed three-storey building was converted by Lincolnshire County Council, supported by the Heritage Lottery Fund, and now houses the Sam Newsom Music Centre – a music and performing arts space. TF 328438.

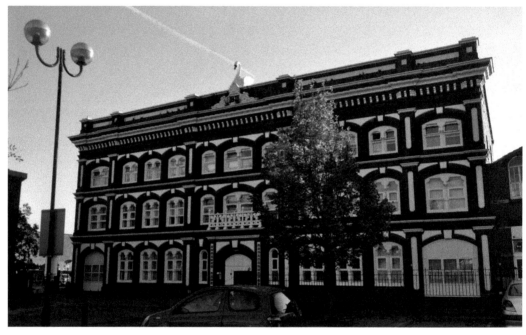

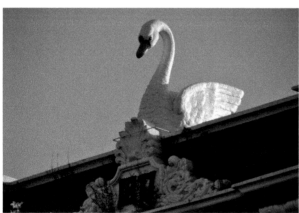

Above: Now converted to flats, the feather factory in Trinity Street, Boston, purified feathers for pillow cases and mattresses.

Left: The swan statue atop the feather factory façade and date stone of 1877.

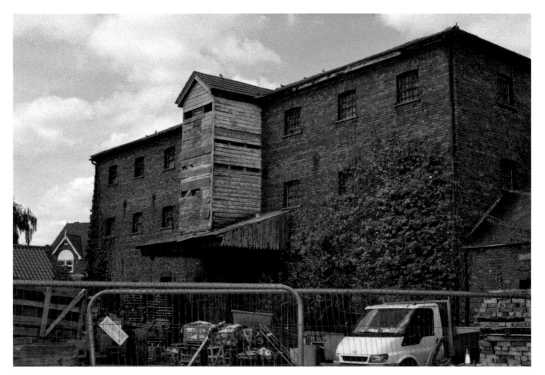

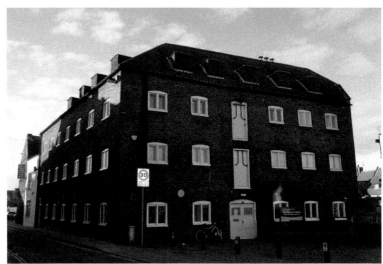

Above: The now derelict Harrison's Grain Store in Horncastle was conveniently located close to the town's railway station.

Right: Lincoln's Grade II listed warehouse on the quayside in Boston is now a performing arts space thanks to lottery funding.

Navigation Warehouse, Louth
A Grade II listed red-brick three-storey building of *c.* 1790, situated on Riverhead Road, built to serve the opening of the Louth to Tetney canal. Along with the nearby Jacksons Warehouse and the Woolpack Inn, they form a significant group of buildings that represent a once prosperous industrial landscape derived from exporting wool and grain. TF 337458.

Pick's Motor Works, Stamford

Situated on the corner of High Street St Martins and Barnack Road, from 1904 until the mid-1920s this was the motor works of John Henry Pick, who built the first motor car in Lincolnshire in 1899. Subsequently a petrol station, it is now an antiques shop. TF 031067.

Sharpe's Warehouses, Sleaford

Two nineteenth-century brick four-storey warehouses, the former premises of Charles Sharpe & Co., seed merchants. One is being let for commercial use while the other has been converted to flats. They are situated opposite the town's railway station, itself a fine example of a country town junction still served by trains from all points of the compass. TF 068455.

Warehouse, Horncastle

Situated on Banks Street, this three-storey brick warehouse of 1890 with an ornate frontage and exterior hoist present was built for Stephen Polloxfen, who was a corn, oil cake and seed merchant. Part occupied as dwellings. TF 261696.

The motor works of John Henry Pick of Stamford, who built the first motor car in Lincolnshire in 1899.

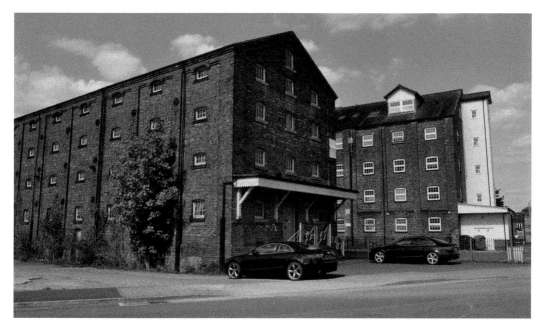

Above: Seed merchant Sharpe's two warehouses opposite Sleaford station – one given over to commercial use and the other converted to flats.

Right: Built for Stephen Polloxfen, a corn, oil cake and seed merchant, this warehouse of 1890 is on Banks Street, Horncastle.

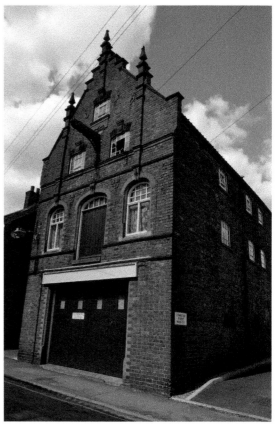

Whitton's Flour Mill, Gainsborough

Gainsborough's once important position in the grain processing and distribution industry is symbolised by Whitton's Mill on Bridge Street. Flour for milling arrived via the adjacent River Trent to this austere 1930s mill, which ceased in 1995. The Whitton name can be seen on the fascia in concrete relief lettering of typical 1930s period. Following fire damage, it has been converted to a retirement housing complex. SK 814896.

Wool Warehouse, Horncastle

Hare & Sons antiques shop on Bridge Street now occupies the 1864 warehouse, built at a time when the wool trade brought much prosperity to the area. Original hoist machinery can be seen within. TF 257697.

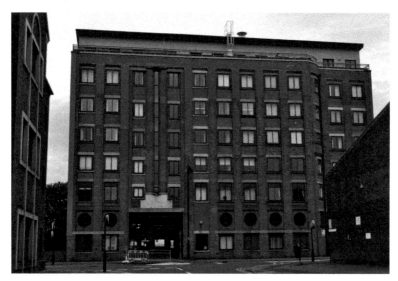

Whitton's Flour Mill in Gainsborough is of 1930s construction. The Whitton fascia name fashioned in concrete relief is typical of the period. Now converted to flats.

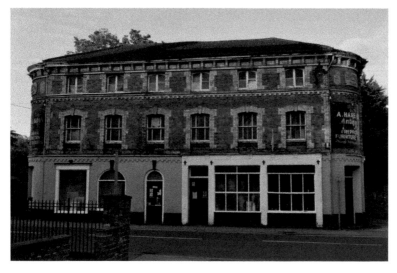

Hare & Sons antiques on Bridge Street, Horncastle, is housed in an 1864 wool warehouse. The wool trade brought much prosperity to the town.

Chapter 8

Watermills

Whilst windmills can be easily spotted in their generally exposed positions, watermills tend to be in wooded valleys and frequently on private land. The selection listed here can be viewed either from the highway or are open to visitors at certain times.

Alvingham Water Mill

There has been a mill on this site since the twelfth century but the present mill brick house and whitewashed lower storey of the mill dates from the eighteenth century, around the time of the Louth Navigation being cut, with nineteenth-century upper-storey extensions dating to *c.* 1820 when machinery was updated. The 11-foot-diameter breast-shot waterwheel is driven by water taken from the nearby River Lud via a culvert under the Louth Navigation and returns to the river via a second culvert under the canal. Restored to full working order in the 1970s, it can be viewed from the end of Church Lane. TF 365913.

Bridge Street Mill, Louth

Situated next to the pretty eighteenth-century balustrade bridge that crosses the River Lud in the centre of Louth, this Grade II listed four-storey red-brick and pantile mill drew water directly from the Lud and was restored and converted to a dwelling between 1973 and 1976 by Louth Civic Trust. The position of two waterwheels can be discerned on the exterior basement wall and the bridge structure incorporates elements of the water control mechanisms that regulated the flow of water to the mill. TF 325875.

Claythorpe Water Mill

Built *c.* 1720 and still operating as a mill until 1977, Claythorpe was the last regularly working watermill in Lincolnshire. The initial waterwheel was replaced by a Victorian-era turbine following a fire in 1903, and this corn mill was fitted out with the latest rollers and several sets of millstones. At this time, an extension was added to the brick building along with a tall chimney for the steam engine's furnace. This chimney was later repurposed for use as a bakery.

Since 1977 the site has been a restaurant and a smokery. The current owners have worked hard since 2013 to develop the visitor attraction and the turbine and some of the old mill works can be seen in the cafe area. TF 414790.

Cogglesford Water Mill, Sleaford

Situated on the west bank of the River Slea just north of the town, with evidence of mills in the area since Saxon times, the present red-brick structure dates from *c.* 1771. Millers have produced flour on the site for over 1,000 years and stone-ground flour can be purchased from the shop. Restored in the early 1990s, a replacement timber-built breast-shot waterwheel has recently been commissioned. Milling days take place on the second Sunday of the month from March to December. TF 074461.

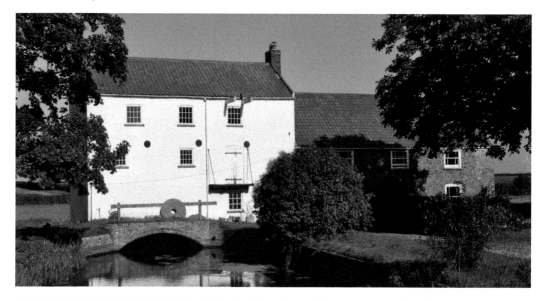

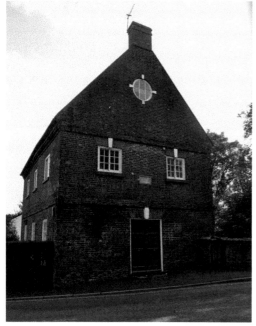

Above: The picturesque Alvingham Watermill was restored to full working order in the 1970s.

Left: The Grade II listed Bridge Street Watermill in the centre of Louth was restored and converted to a dwelling by Louth Civic Trust in the 1970s.

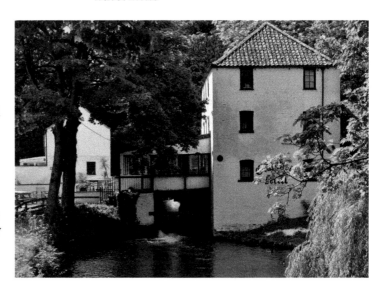

Right: Until the 1970s, Claythorpe was the last regularly working watermill in Lincolnshire. The initial waterwheel was replaced by a turbine.

Below: Restored in the early 1990s, a replacement timber-built breast-shot waterwheel has recently been commissioned at Cogglesford Watermill at Sleaford.

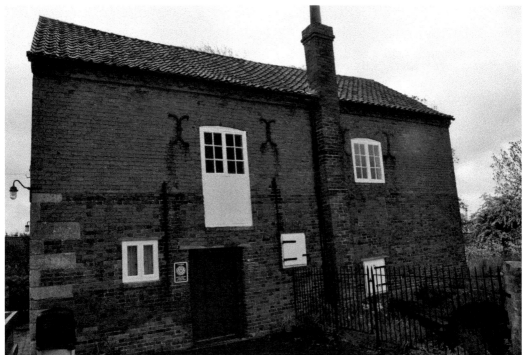

Hibaldstow Water & Windmill

Two for the price of one! A very rare surviving example of a mill that combined a windmill and watermill and living accommodation in a single building. Built in 1802 by local millwright James Middleton, an additional floor was added to the tower in 1837 and was home to the miller and his family until the 1880s. The undershot wheel was removed in 1912, the four sails in 1913 and the ogee cap in 1924. The final indignation

was to fill in the mill pond in the 1940s. Nonetheless, it is a design that is probably unique. It can be viewed from Ings Lane. SE 982027.

Hubbard's Hill Mill, Louth
A former corn mill and attached bakehouse, this limewashed brick structure of the early nineteenth century is situated at the eastern end of the Hubbard's Hills Country Park on Crowtree Lane. The sluice and waterwheel survive in the grounds of what is now a delightful private house. TF 318869.

Ketsby Water Mill, South Ormsby
An unassuming yellow-brick two-storey Grade II listed mill house of 1864. Two grinding stones and hoppers are intact on the first floor, with gearing and shafts linked to a cast iron breast-shot waterwheel, one of the last iron wheels to turn in Lincolnshire. Now a private residence. TF 369767.

Little Carlton Water Mill
Viewed from the road to Great Carlton, this three-storey brick mill still contains an iron drive wheel and spindle to an iron overshot wheel on the right-hand side. The wheel was supplied by Saunderson of Louth. The watermill and wheel are listed but the adjacent mill house is not. The needs of the local populace were met from the detached bakehouse, a rare survivor. TF 401854.

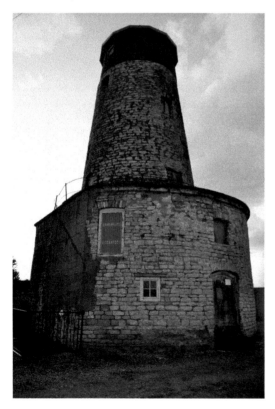

A design that is probably unique! Hibaldstow is very rare survival of a mill that combined a wind and watermill and living accommodation in a single building.

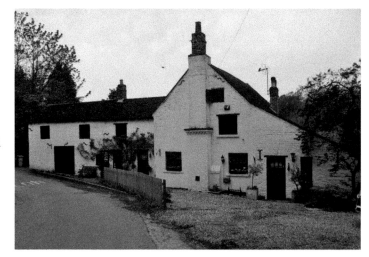

Hubbard's Hill Watermill in Louth milled corn with an attached bakehouse, which is now a private house. The waterwheel and sluice survive in the grounds.

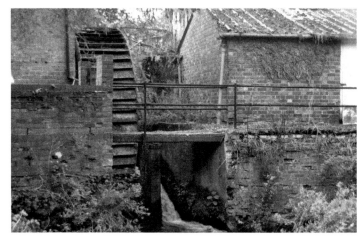

One of the last cast iron waterwheels to turn in Lincolnshire, the machinery remains intact at the privately owned Ketsby Watermill.

The mill and waterwheel at Little Carlton are listed but the adjacent mill house is not. The wheel can just be discerned to the right of the building.

Stockwith Water Mill, Hagworthingham

Built to grind corn for the Harrington Hall estate until 1919, this Grade II listed building boasts an external timber and iron waterwheel on a timber axle, situated on the east bank of the River Lymm. It later powered an electricity generator and was used regularly until 1960. The setting is believed to be 'Phillips Farm' in Tennyson's poem 'The Brook'. TF 358705.

Tetford Water Mill

A bakehouse and miller's house situated on Mill Lane and in use until the spring of 1947, when milling finished due to the exceptional weight of snow melt water causing the sluice to jam. The baking of bread and scones continued until 1961 and in 1963 became the premises of the village doctor, who held surgeries in the outbuildings and had the mill pond filled in. TF 332745.

Thoresway Water Mill

Standing alone in the centre of the village, the whitewashed brick building houses an internal waterwheel erected *c.* 1818 to provide power via an overhead leat fed from a pond on the hillside. A cog and axle arrangement then transferred power via a chamber under the road to a farm building to power its agricultural implements. A ninety-four-year-old acquaintance of the author recalls the operation being in working order when he was a lad growing up in the village. The wheel survives in the building but is not open to visitors. TF 165966.

Tyson's Watermill, Tealby

Situated on Thorpe Lane in this lovely village on the Wolds, this fine stone-built private residence was built *c.* 1790 and powered by an external breast-shot wheel, which was later replaced by a turbine. The site of the waterwheel can be viewed on the left-hand side of the building. TF 155903. A further watermill at Tealby Thorpe, 1 mile south-west of Tealby, can be viewed from the road at TF 150900.

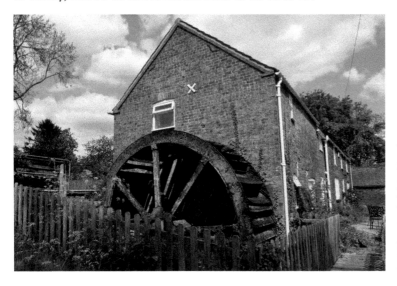

The timber and iron waterwheel at Stockwith Mill near Hagworthingham was used regularly until 1960 and ground corn for the Harrington Hall estate until 1919.

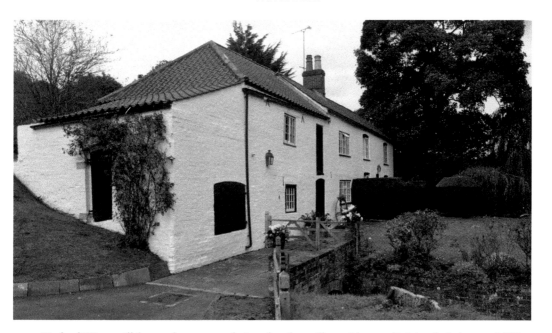

Tetford Watermill boasted accommodation for the miller, with an adjoining bakehouse. Milling finished in 1947 but baking continued until 1961.

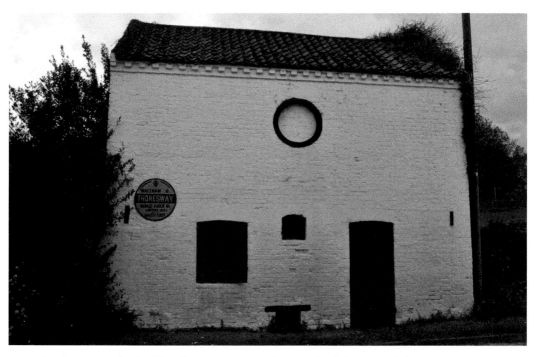

At Thoresway, this building houses an internal waterwheel that provided power via an overhead leat and power transferred via a cog system under the highway to a farm building to power the implements. Note the vintage AA enamel roundel on the wall.

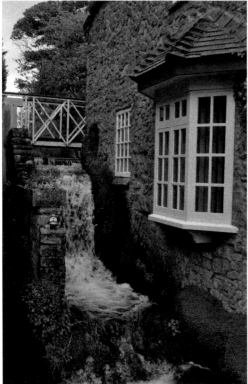

Above: The fine stone-built Tyson's Watermill at Tealby, built around 1790 and now private accommodation.

Left: The site of the breastshot wheel at Tealby where the leat is in full flow.

Chapter 9

Windmills

Harnessing the power of wind to turn stones, by which corn could be ground into meal to make bread to sustain the local population, was introduced to Britain from France in the twelfth century.

Lincolnshire is blessed with some fine surviving examples of windmills, which once numbered well over 400. Remains of 136 windmills can still be found today. The strong storms of recent years have not been kind to Lincolnshire mills in sail, with those at Alford, Burgh-le-Marsh and Sibsey currently sail-less and undergoing restoration.

A tower mill is usually constructed of brick or stone, with a cap that is capable of being rotated to bring the sweeps (sails) into wind.

A post mill is of wooden construction, balanced upon a centre post on which it pivots to face the wind direction and turned by a miller pushing the tailpole.

A smock mill is a timber tower, usually of weatherboard, surmounted by a cap that rotates to bring the 'sweeps' into wind. Said to resemble a shepherd's smock.

Tower mills (mostly now sail-less) survive in number throughout Lincolnshire, with a well-preserved example of the rarer post mill type at Wrawby. Post mills were once the most numerous throughout the UK, but we are now down to just forty-two examples nationwide. Smock mills are also rare in Lincolnshire and the example in the village of Dyke, near Bourne, is the last to exist in the county. A selection of mills that can be seen from the highway are featured here.

Alford Windmill
A seven-storey tower mill built in 1837 by Sam Oxley, it is the sole-survivor of a group of four mills in the area. Generations of the Hoyles family operated the five-sailed mill until 1955. Following storm damage the mill on East Street is unfortunately currently sail-less and closed to visitors pending repairs. TF 457766.

Barton-on-Humber Windmill
A seven-storey brick tower mill near Market Place and now part of the Old Mill public house and restaurant. Built c. 1910, it once boasted six sails and ground grain and chalk for whiting. The adjoining granary buildings that form the public house are later nineteenth-century additions. The corn grinding machinery has been preserved. TA 032218.

Dobson's Windmill, Burgh-Le-Marsh

Another Sam Oxley of Alford-built five-storey, five-sailed mill, this one has unusual 'left-handed' sails and therefore rotate clockwise. Built for the Jessop family and last worked by a Mr Dobson, the mill was purchased by the local council in the 1960s and refurbished.

Unfortunately the cap and sails were destroyed by high winds on the night of 9 February 2020 and the site remains closed for repairs. TF 503649.

Dyke Windmill, Dyke near Bourne

The last remaining smock mill in Lincolnshire, first constructed *c.* 1650, it was used for powering water pumps as a drainage mill in nearby Deeping Fen. In 1845 it relocated to its current location in Dyke village, half a mile north of Bourne, and converted to a corn mill with three pairs of stones; two for producing flour and the third pair for grinding cattle feed. A flour dressing machine was added in which the wholemeal ground flour was dressed by passing it through a silk screen to produce white flour. The current owner also runs an adjacent art gallery open to visitors. TF 102226.

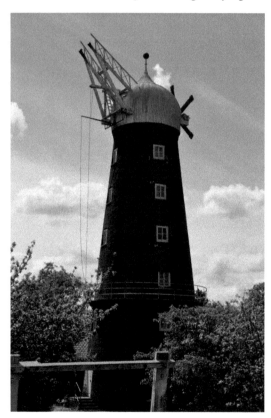 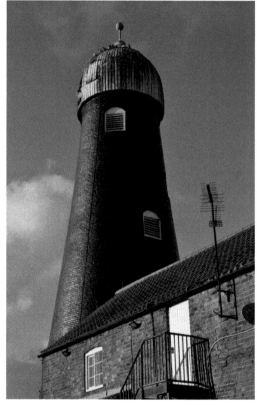

Above left: The normally five-sailed Alford Windmill is currently sail-less, pending repairs to storm damage.

Above right: Barton-on-Humber Windmill is now part of the Old Mill pub and restaurant.

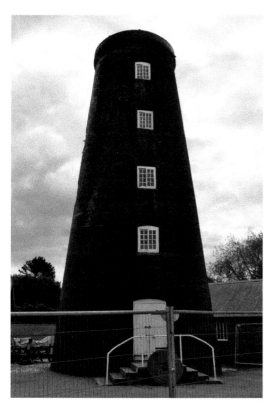
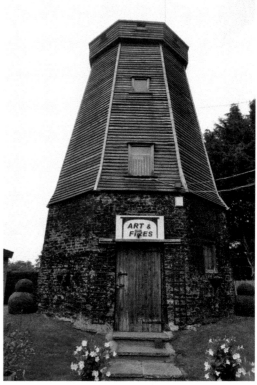

Above left: The cap and five sails of Dobson's Windmill, Burgh-Le-Marsh, were destroyed in a storm in February 2020.

Above right: The last remaining smock mill in Lincolnshire is at Dyke, near Bourne.

Ellis's Windmill, Lincoln
The last working mill in Lincoln, a brick tower mill with four sails and three storeys built in 1798. Restoration from burnt out condition to working order started in 1977 and was completed in 1981 as Lincoln Civic Trust's celebration of the Queen's silver jubilee. Situated next to, and managed by, the adjacent Museum of Lincolnshire Life, which is also worth a visit. SK 972721.

Hanson's Windmill, Burgh-Le-Marsh
A Grade II listed tower mill dated to 1855. The four sails were removed in 1938 and the machinery in 1964. The machinery was taken to Brixton Windmill, London, where restoration by London County Council was taking place. The remaining tower has now been incorporated into a fine dwelling and bed and breakfast establishment. TF 498651.

Heapham Windmill, near Gainsborough
A Grade II listed tower four-storey mill dating from 1876 for cereal milling, replacing an earlier post mill. Abandoned after lightning struck in 1956. Currently bereft of its four sails, it can be viewed from the public road. SK 874887.

Heckington Windmill

Arguably the most impressive windmill in the county, the Grade I listed mill at Heckington is the only eight-sailed tower windmill still standing in the UK with its sails intact and also retains most of its internal equipment. Due to its large sail area and well-winded site next to Heckington railway station, the mill is able to drive four pairs of millstones and is able to work in very light breezes that other mills cannot. The tower was built in 1830 and the cap and sails were brought from Boston in 1892. Restored by Lincolnshire County Council and now run by the Heckington Mill Trust, the mill is open to visitors daily in high summer and weekends and bank holidays at other times. The mill is close to the 'Pea Room', an 1890 warehouse built for sorting and packing peas. TF 144435.

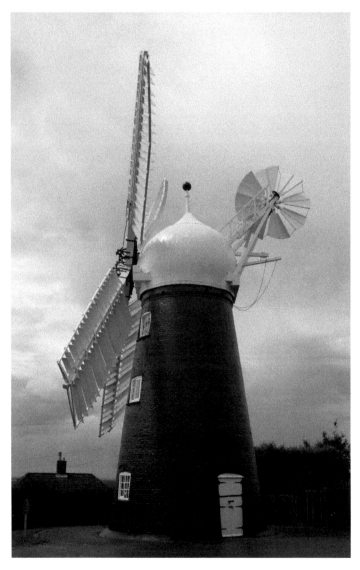

Left: Ellis's Windmill was the last working windmill in the city of Lincoln. (Phil Barnes)

Opposite above: The remaining tower of Hanson's Windmill in Burgh-Le-Marsh is now a B&B establishment.

Opposite below left: Currently bereft of its four sails, Heapham Windmill near Gainsborough.

Opposite below right: The impressive Heckington Windmill, the last eight-sailed tower mill still standing in the UK.

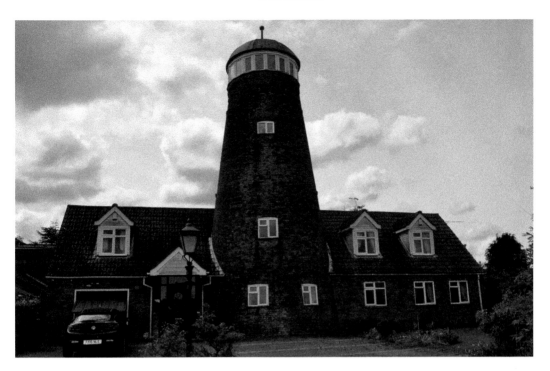

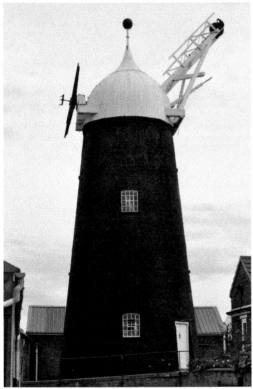

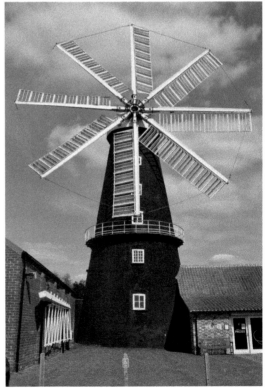

Holbeach Windmill
Known as Penny Hill Mill, this brick Grade II listed tower mill remains derelict. Built in 1827 on the site of an earlier smock mill, it can be viewed from the road a mile north of Holbeach. TF 358267.

Holmes Windmill, Horncastle
The last example from five windmills that were once sited in this market town. A derelict brick tower mill viewed from the Spilsby Road east of the town centre, built in 1843 with seven storeys and five sails. The sails were removed in 1916 and the mill continued to work by steam power until the 1940s. The two upper storeys were removed in the 1970s. TF 266696.

Kirton-in-Lindsey Windmill
A four-storey tower mill built in 1875, known as Mount Pleasant Mill, replacing an earlier post mill. Operated by wind until 1936 and then powered by a Crossley oil engine until 1973. Restored to wind power in 1991 but currently sail-less (four sails) with adjacent tearoom and shop. SK 939994.

Mareham le Fen Windmill
Known as Chatterton's Mill, a four-sailed tower mill built as four storeys in 1820 and raised by extending to six storeys later in the century. The sails were removed in 1910 and the cap and fantail followed in 1939. Can be viewed from the main street through the village. TF 281610.

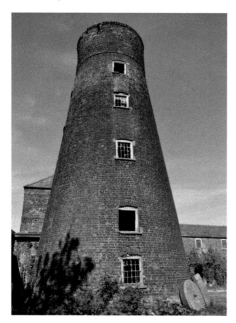 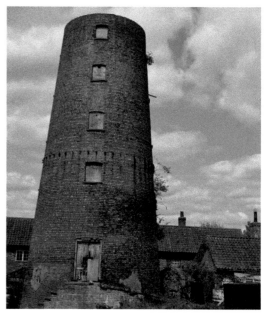

Above left: Holbeach Windmill is Grade II listed but remains derelict.

Above right: The derelict Holmes Windmill in Horncastle, the last example of five that were once in the town.

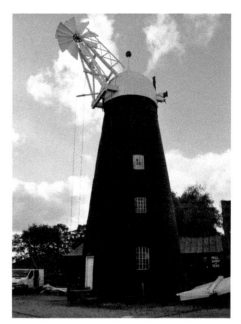

Right: Kirton-in-Lindsey Windmill was restored to wind power in 1991 but is currently sail-less.

Below: Mareham le Fen Windmill's sails were removed in 1910 but the tower is in good order.

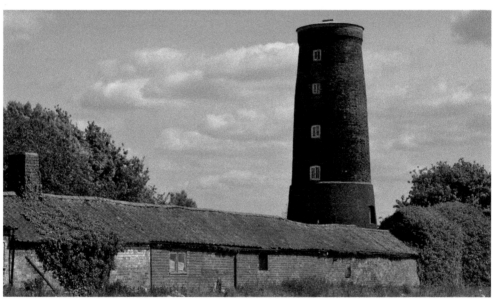

Maud Foster Windmill, Boston

A six-storey tower mill with five sails, built in 1819 for brothers Isaac and Thomas Reckitt by Hull millwrights Norman & Smithson. A bakehouse was added in the 1820s and a 16 hp steam beam engine was installed by local firm Tuxford. Restored in the 1990s and in the safe hands of steam engine owner James Waterfield and family. The mill celebrated its 200th birthday in 2019 with a steam-up of Boston-built Tuxford-built portable engines in the mill yard. TF 332447.

Money's Mill, Sleaford

Standing incongruously in a public car park in the centre of town, this brick tower mill of *c.* 1794 was raised slightly in around 1810 to become eight storeys. It worked by wind until 1903 and then an oil engine took over. Now without sails or machinery it became Sleaford's Tourist Information Office and then a café on the ground floor, but there is currently no sign of any commercial use. TF 068457.

Morton Windmill, near Gainsborough

A five-storey brick tower mill built in 1820 and abandoned by 1899. The surrounding buildings were demolished by 1994 when the mill was converted to an office. Its ogee cap has been restored. The ground floor contains a reinforced concrete strong room when used in the Second World War as a Home Guard base. Privately owned but can be viewed from the road. SK 811921.

Moulton Windmill

A colossal four-sailed brick tower mill of nine storeys, believed to be the tallest surviving in Britain at 100 feet high to the top of its ogee cap.

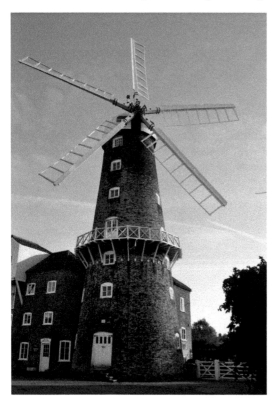
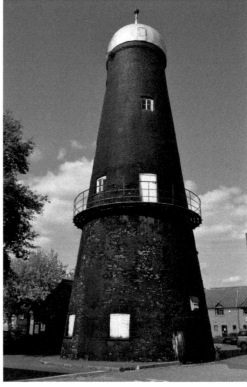

Above left: The five-sailed Maud Foster Windmill in Boston is a well-known landmark in the town and was restored in the 1990s by the current owner.

Above right: Money's Mill of *c.* 1794 stands sentinel in a public car park in the middle of Sleaford.

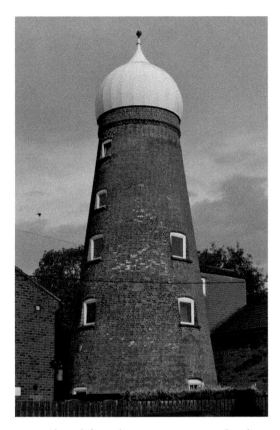

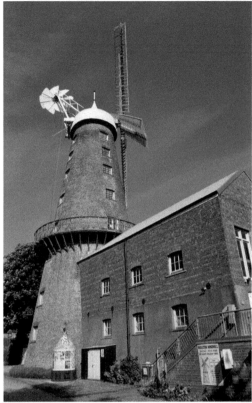

Above left: With its ogee cap restored and in good condition, Morton Windmill near Gainsborough was abandoned by 1899 but now serves as offices.

Above right: The nine-storey Moulton Windmill is believed to be the tallest survivor in Britain at 100 feet high.

Built *c.* 1822 by Robert King, the sails and cap were removed in 1894 following gale damage and a steam mill was subsequently installed. A grain merchant owned the mill from 1924 to 1995 and the engine drive gearing has been retained in the basement. Now owned by a registered charity and open at weekends and bank holidays. TF 307240.

New Bolingbroke Windmill
There were two working windmills in New Bolingbroke. The surviving stump of Watkinson's Mill is used for storage but Rundle's red-brick five-storey tower mill is Grade II listed and dates from the 1820s. It has been disused since 1906 but is in the good hands of J. R. Rundle & Sons, engineers, who are well-known in the world of preservation for their collection of old engines and fairground artefacts. TF 307585.

Sibsey Trader Windmill
One of the last tower mills to be erected in Lincolnshire, constructed by local millwright John Saunderson of Louth in 1877. This six-sailed mill worked commercially until

1954 and was earmarked by the Ministry of Works in the 1960s as one of twelve windmills of national importance. Open to visitors since 1981 after restoration work by Thompsons of Alford with further restoration completed in 2002 by owners English Heritage. Currently without sails, storms in January 2018 caused significant damage and the decision was taken to remove the sails and fantail with a view to full restoration. The only other surviving six-sailed mill in the county is at Waltham. TF 344510.

Waltham Windmill

A brick tower mill of six storeys and six sails completed in 1880 by John Saunderson of Louth and designed to also operate under steam power. It ceased to work commercially in the 1960s and was later restored to full working order by Cleethorpes District Council. Now part of a complex of tourist-led shops with a miniature railway in the adjacent park. The mill is maintained by the Waltham Windmill Preservation Society and is open at weekends. TA 259033.

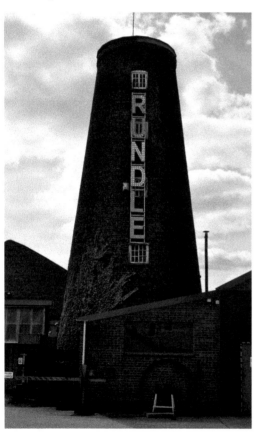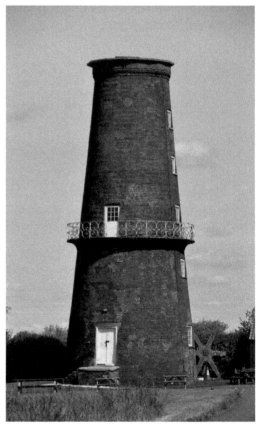

Above left: New Bolingbroke Windmill has been disused since 1906 but is in the good hands of engineers J. R. Rundle & Sons.

Above right: Sibsey Trader Windmill is owned by English Heritage and its six sails and fantail were removed following storm damage in January 2018.

Wragby Windmill
Situated on Bardney Road, this Grade II listed tower mill was built in 1831 with seven storeys and six sails. Steam power replaced wind power in 1903 and an oil engine was used later. Although now sail-less, it was refurbished and re-tarred at the millennium. TF 131778.

Wrawby Post Mill
The earliest reference of milling in Wrawby is in 1585, although the current mill dates from 1760–90 and was in operation until 1940. Used for grinding wheat for human consumption and barley and oats for animal feed. The last example of a post mill in Lincolnshire, it was restored from burnt-out dereliction in 1965 and is now Grade II listed. A number of open days are held each year. TA 026088.

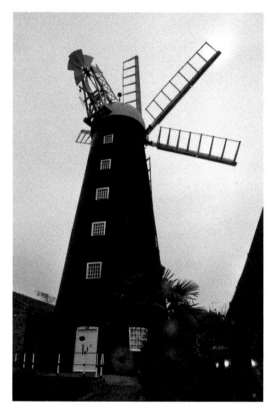

Above left: The six-sailed Waltham Windmill is maintained by a local group and is open at weekends.

Above right: The Grade II listed Wragby Windmill once boasted six sails and was re-tarred at the millennium.

Bibliography

For those who wish to know more about the county's history or be involved, contact the Society for Lincolnshire History and Archaeology at Jew's Court, Nos 2–3 Steep Hill, Lincoln, LN2 1LS.

Hinde, K. S. G., *Fenland Pumping Engines* (Ashbourne, Derbyshire: Landmark Publishing Ltd, 2006).

Nott, Hugh., *Papermaking in Lincolnshire 1600–1900* (Lincoln, Lincolnshire: Society for Lincolnshire History and Archaeology, 2008).

Squires, Stewart E., *The Lincolnshire Potato Railways* (Usk, Monmouthshire: The Oakwood Press, 2005).

Wright, Neil, *Lincolnshire's Industrial Heritage – A Guide* (Lincoln, Lincolnshire: Society for Lincolnshire History and Archaeology, 2004).